Desire to Inspire

A COLLECTION OF
USEFUL AND FAMILIAR QUESTIONS AND ANSWERS
ON EVERY-DAY SUBJECTS,
AND ARRANGED IN THE MOST SIMPLE AND EASY
LANGUAGE.

BY A LADY.

A PEEP INTO THE WIDE WORLD.

"STRANGERS WALK AS FRIENDS"

DIFFICULTY OF DOING RIGHT

"SOMETHING TURNS UP".

NIGHT AND MORNING

SWEEPING AND DUSTING

FLOWERS AND THORNS

THIS "WORKING-DAY WORLD".

THOUGHT IS FREE

THE WIDE WORLD GROWN WIDER

Authorized Edition.

B
C
D
F
G
H
I
J
K
L
M
Mᶜ
N
O
P
Q

Desire to Inspire

Using Creative Passion to Transform the World

Christine Mason Miller

NORTH LIGHT BOOKS

www.CreateMixedMedia.com

THIS BOOK IS DEDICATED TO
KAREEM, SUKAYNA AND ZAIN:
NEVER DOUBT
THE POWER
OF YOUR DREAMS
TO TRANSFORM
THE WORLD.

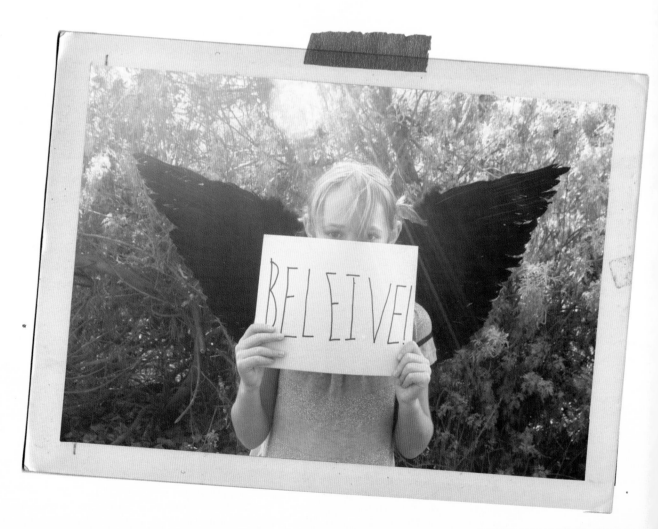

PHOTO BY MCCABE RUSSELL

the lute will beg
By Hafiz

You need to become a pen
In the Sun's hand.

We need for the earth to sing
Through our pores and eyes.

The body will again become restless
Until your soul paints all its beauty
Upon the sky.

Don't tell me, dear ones,
That what Hafiz says is not true,

For when the heart tastes its glorious destiny
And you awake to our constant need
For your love

God's lute will beg
For your
Hands.

PHOTO BY ANNE CARMACK

PHOTO BY CHRISTINE MASON MILLER

contents

ARTWORK BY LIZ KALLOCH

introduction

I am not a jump out of bed, leap into the day kind of person, a characteristic that has lately felt more pronounced in contrast to my puppy's morning excitement. As I throw aside the covers, slowly sit up and loopily make my way to the bathroom to brush my teeth, Tilda is all wagging tail and bounding energy. "It's a new day!" she seems to say, "What could possibly be better?" Groggy and already imagining a perfect cup of coffee, I cannot help but be inspired by her eager, happy response to each morning, day after day after day.

A little while later, with coffee in hand, I begin to wake up and get my day going with a virtual journey around the world to see what my friends and colleagues are up to. I check in with Pixie Campbell, whose fierce devotion to the truth of her journey as a woman, a mother and an artist never fails to add fuel to my own internal creative fire. From there I go to Vineeta Nair's design blog, where her latest photographs from Mumbai, India fill my head with ideas for a new series of artwork, not to mention another journey abroad. After this I'll see what Amy Krouse Rosenthal is up to and then visit Liz Kalloch. I love reading Anne Carmack's latest musings and I find it is always a good idea to keep up with Christine Castro Hughes, whose artistic, colorful, gratitude-infused view of the world reminds me to pay attention to the details.

By the time I've read the words and musings of these women—which chronicle everything from building a business to coping with disappointment—my energy has begun to sparkle and I'm inspired to get to work. They fill that quiet space between waking up and getting to work with light, inspiration and the same kind of excitement I see in Tilda when her head pops up on the side of my bed—the joy of beginning a new day, which holds new opportunities to share and express my creative, flawed, talented, contradictory, messy, grateful self.

I check in with these women and many others on a regular basis for one simple reason: They inspire me. I visit their websites and read their blogs because they feed my soul and encourage me to keep doing the work I do, which is, like theirs, fundamentally about making the world a better place. They encourage me with their honesty, creativity and spirit; they show me what it means to live a passionate, mindful life. I see their work and read their stories and they motivate me to take risks, work hard, express myself and share the ups and downs of my journey with absolute honesty.

Ever since the day I went to Santa Barbara City Hall to apply for my very first business license, my mission has not been to simply be an artist, but to create art that inspires others to follow their passions. I launched my artistic venture with an unwavering belief in possibility, which provided a foundation that has supported me through fifteen years of ups, downs and quiet in-betweens.

During this time I have met, collaborated with and become close to an extraordinary community of like-minded souls—artists, writers, activists, entrepreneurs, workshop leaders, personal coaches, designers, and filmmakers—who walk through this world not content to pursue their passions exclusively for their own joy and benefit, but for the deeper purpose of making the world a better place (although what I'll try to demonstrate in this book is that these two endeavors are, at their core, one in the same.) Time and time again, when I've asked these women what they really want to accomplish with their work, they give the same answer: "I want to inspire others."

It is this profound desire to inspire that drives the day in, day out work of pursuing our passions, which is done in the midst of raising children, building marriages and doing all the other requisite caretaking that falls on the to-do lists of most women. We write stories and prepare meals, design books and do laundry. We gather online, over coffee, and at organized retreats, sharing our experiences of all the ways we are able to create a meaningful life through our work, our families and our communities. And yes, we all do this because it fulfills us and makes our hearts sing. But when we explore the deeper reasons behind this time and effort, there is something even more important than what these pursuits do for us, and that is our desire to shine a light in the world that others might need to take their own daring leaps.

In a nutshell, we have all chosen to center our creative and professional lives around one shared mission: serving others.

Desire to Inspire: Using Creative Passion to Transform the World aims to explore what it means to live a meaningful, inspiring life and how many of today's leading artists and visionaries have figured out how to do this—to express, embody and share their messages, gifts, philosophies and beliefs in the midst of all the twists and turns life has given us.

Through heartfelt interviews with nineteen women who are changing the world for the better in their own unique way, I hope to shed some light on the roots of what it means to live a mindful, passionate life and how and why this is the greatest service one can offer the world. It is one thing to talk about why I love to paint or write a story and something else to talk about why it is important that those acts somehow make the world a better place. I have asked these women to peel back another layer to expose whatever experiences and influences led to their commitment to being a Force of Good in this big, weary, beautiful, complicated world of ours. Not surprisingly, they have responded with total candor and sincerity, reflecting the wisdom, grace and beauty that so many people the world over, including myself, are drawn to.

As you read these pages, I think you will agree that these women are not creating light and joy in the world simply through their books, photographs, messages and teachings, but through the lives they live every day. In different ways, these women encourage others to pursue their passions not only because they literally say those words in one form or another, but because they set an example for it; their actions back up their words, their lives are a testament to the power of dreams.

CHRISTINE MASON MILLER
SANTA MONICA, CALIFORNIA
MAY 2011

Your winGs already exist.
ALL You have to do
is FLY

ARTWORK BY CHRISTINE MASON MILLER

PHOTO BY CHRISTINE MASON MILLER

chapter one

a force of good

When We Care for Ourselves,
We Care for the World

66 Being a Force of Good in the world and honoring
my core values is about saying yes to my heart
and saying yes to the hearts of those who pass
through my life. It is about being willing to
stand as close to the flame of truth as possible
and meeting each day with as much integrity and
honesty as I can muster. **99**

Liz Kalloch

"BEING A FORCE OF GOOD IN THE WORLD MEANS ALLOWING MY HEART TO BE OPEN TO THE TRUTH THAT WE ARE ALL CONNECTED AND TO THE IMPORTANCE OF SERVING THE PERSON WHO IS RIGHT IN FRONT OF ME." —MARIANNE ELLIOTT

Not long ago, I reached an emotional low point after an arduous discussion with my husband that went late into the night—a painful yet necessary exchange that forced us both to lay our deepest longings and vulnerabilities on the kitchen table between us. Despite my fears around everything that had just been exposed, I knew it was a moment ripe with possibility. There was now nothing left to hide or run away from, and this meant it was time to make a choice—toss my armor aside or begin to rebuild it.

Soon after the conversation ended, I reached out to my friend Marianne Elliott, a United Nations (UN) Human Rights Officer, looking for the guidance and wisdom of a woman with a unique, and perhaps dismal, view of suffering in the world. I longed for a few words of kindness, but also speculated that a sterner response would be fitting. Thinking a certain "reality check" would be the most effective way to snap me out of my emotional tailspin, and believing I deserved nothing more, I wrote, "You've seen the worst of the world and heard stories from people who lost everything—do I just need to get over this?"

Instead of a reproach, Marianne responded with the same thoughtful understanding she has given to refugees and victims of tribal warfare in Afghanistan, the Gaza Strip and East Timor, guiding me along a path of openhearted compassion toward myself. In doing so, her empathy and kindness meant the difference between going to bed with a steady grip on the fears unearthed that evening or making a commitment to let them go. What began the following morning was not merely a new day, but a new beginning—for myself, my marriage and our family—that started with Marianne, and the gentle words she sent across the Pacific, to a barely lit kitchen in Santa Monica.

Marianne's most recent tour with the UN finished in Ghor, Afghanistan at the end of 2007. She has since written a book about her experiences, become a certified yoga instructor and consulted for a variety of humanitarian organizations, all from her native New Zealand. Her website offers readers insights into grassroots social change, Twitter advice and interviews with other "change-makers" around the world. After doing work that transformed the lives of Afghan civilians through advocacy and education, she now inspires readers across the globe through her writing, teaching and consulting. In other words, she is a Force of Good, whether in war-torn countries, at a yoga conference in California, or sitting quietly in her home, offering unconditional support in an e-mail to a friend.

"I have always been deeply moved by human suffering everywhere, with a burning desire to 'Save The World,'" Marianne explains. "I've learned that I can start by saving the little bit of the world that is within my reach—by serving the people right in front of me—because I really never know how far an act of kindness can reach, no matter how small."

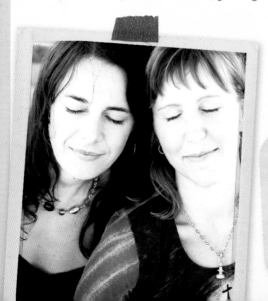

PHOTO OF MARIANNE ELLIOTT (L) AND CHRISTINE MASON MILLER (R) BY SUSANNAH CONWAY

66 Be humble, be generous and keep your mind and eyes open. 99
Andrea Kreuzhage, on being a Force of Good

> **❝** Each individual, regardless of circumstance, holds a unique gift to share with the world and as such, it is important to radiate hope and courage for those who have yet to discover what is within them. **❞**
>
> Carolyn Rubenstein

PHOTO BY TRACEY CLARK

Being a Force of Good feels like a grand statement, something requiring a red-wax sealed document and a chorus of trumpets. It has a global weight and feel to it, as if to imply intentions must be big in order to be impactful. Sometimes this seems true, with leaders like Oprah Winfrey, Bono and Bill Gates providing examples of what is possible when we set our minds to making a positive difference in the world. But for those of us who aren't media mavens and rock stars, it is tempting to let ourselves feel powerless and believe our choices and actions don't really matter—toward ourselves or anyone else.

"IT IS NOT ONLY MY PASSION BUT A RESPONSIBILITY TO LIVE AND TEACH WHAT I BELIEVE: THAT BEAUTY IS EVERYWHERE, THAT WE ALL DESERVE TO LOVE AND BE LOVED AND THAT LIFE IS REALLY ALL IN THE WAY WE LOOK AT IT." —TRACEY CLARK

In any given week, I run errands, write, wash dishes, visit friends, read and walk my dog. These are things many people do, things that are very ordinary and mundane. But it is in those everyday routines and details that I aim to be a Force of Good. This usually requires nothing more than looking a checkout clerk in the eye and saying, "Thank you" (a gesture that consistently results in a double take, the clerk surprised at being acknowledged), or responding to an e-mail from a young art student seeking professional advice. Most of the time I channel my desire to be a Force of Good through tiny pinholes—a moment here, five minutes there—always mindful of how impactful these small opportunities for kindness can be.

This awareness expands and deepens in direct proportion to my willingness to grant myself the same generosity. The same rule of scale applies—gestures need not be grand to practice meaningful self-care. As life coach and writer Kate Swoboda explains, "My work is to start with staying connected with myself so that I can be present and connected with others."

You might think Marianne Elliott taught me about compassion through her example as a UN Human Rights Officer—and she did to a certain extent—but the more meaningful examples have come in much smaller moments. It is in how she chooses to face and interact with everyone she comes into contact with—whether friend, stranger or prickly acquaintance—and all the ways she approaches and acknowledges her own vulnerabilities and fears, a process she shares on her blog. The example she sets for loving-kindness toward herself is at the center of all the ways she aims to inspire others, the anchor that provides a solid support system for all of her outward expressions of goodness.

66 I believe I am doing the world the most good when I find the courage to participate in life from a place of unbridled honesty and humor. 99
Anne Carmack

PHOTO BY ANNE CARMACK

VINEETA NAIR REFLECTS ON ARTNLIGHT

Inspiring myself on a daily basis is oxygen to my being and doing, and my desire to inspire is a lamp at my heart. The light that goes in goes out as well. It is not something I do with any conscious agenda, but is born out of my determination to hold out against my own demons. It is an offshoot of my belief that art and creativity are not meant for a select few. It is a result of my conviction that we can all be happy and live the life we want. Writing my blog is one of the more tangible exchanges of inspiration available to me—offering and receiving ideas, insights and even objects of beauty empowers and keeps me going.

At the beginning of 2010, I created a mood board for my design blog. It was meant to reflect my 'Artnlight' way of seeing things and it was more challenging than I expected at first. Once I got going—pulling out images that appealed to me—it slowly began to take shape and I was able to create something that made my heart shine in recognition of what I was looking to share and express with my blog. What I was reminded of during this process is that this blog, along with offering eye candy India-style, is really about inspiration. I write this blog because I feel inspired by what I see, read and experience. If, in turn, it inspires others, then I have fulfilled my most personal mission.

Visit www.Artnlight.blogspot.com for more colorful, inspirational goodness from Vineeta Nair.

PHOTOS BY VINEETA NAIR

66 When I am happy, I spread happiness.99
Vineeta Nair

"BEING A FORCE OF GOOD MEANS TO ANSWER THE SOUL'S CALL AND CARRY THIS DIVINE, CREATIVE LIGHT FORWARD TO SHINE ON THOSE PLACES THAT COULD USE SOME ILLUMINATION." —PIXIE CAMPBELL

We all have a divine light within us and when we choose to share it, we leave a positive imprint on the world. By putting this into practice in the smaller spaces—in an e-mail, at the grocery store, with our families—we build our inspirational and compassionate muscles, which can then be flexed in other, perhaps "bigger" ways, such as situations that feel more challenging. Pixie Campbell is an artist, writer, wife and mother of two whose foundation of goodness rests on the life she creates for her family, a life that is built in support of the creative endeavors of everyone under their roof. On her blog, Pink Coyote, Pixie speaks to the sparkling, fluid interplay between the passions that inspire her family:

"When we began our family, our creative lives slowed down dramatically, but they've since evolved unexpectedly as we've learned how to assimilate and integrate the new insight and inspiration that comes with being parents. As we support our artistic endeavors as individuals, we provide an example that encourages our children's creative aspirations, providing a steady stream of fertile, imaginative goodness that feeds us all." October 12, 2010

For Pixie, being a Force of Good begins squarely at home and extends outward through artwork and writing she creates and shares between bath time, nature walks and temper tantrums. The example that inspires detailed drawings by her five-year-old son Miles is the same one celebrated by admirers of her blog and artwork. She explains, "Allowing ourselves to be exactly who we are in the moment gives our loved ones and those we cross paths with permission to do just the same." By honoring and answering her "soul's call"—which frequently requires late nights in her studio while her family peacefully slumbers—she secures all the provisions she needs to venture out into the world with light, goodness and heaps of inspiration.

Author Jennifer Lee supports this notion when she says, "Being a Force of Good in the world means making a positive difference by shining your gifts brightly and empowering others to shine their gifts brightly, too."

18

PHOTO OF JENNIFER LEE BY DANIELLE SAUNDERS

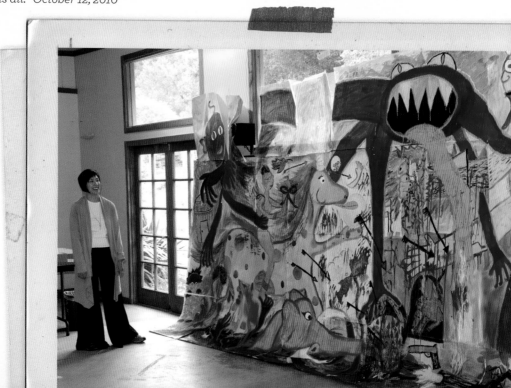

Make It Real

"BEING A FORCE OF GOOD IN THE WORLD MEANS WORKING TO SEE THE LIGHT WITHIN MYSELF, RECOGNIZING THAT LIGHT IN OTHERS AND HELPING THEM SEE IT FOR THEMSELVES."
—PENELOPE DULLAGHAN

Each day we are called upon to wear a multitude of different hats. As we march here and there to do The Things We Need to Do, we leave small and large traces of ourselves behind. Are the impressions we leave positive? Is what we choose to share and express uplifting? Whether fixing breakfast for our families, working to rebuild war-torn countries, or writing a blog entry about a creative breakthrough, we have one opportunity after another every day to be a Force of Good, regardless of our job title, zip code or hair color. It is about honoring our spirits so we can more fully support those around us, and creating the greatest capacity for kindness and compassion toward others by showing the same consideration toward ourselves.

ARTWORK BY PIXIE CAMPBELL

66 As a Force of Good in the world sharing inspiration and support, my life is filled with wonder, awe and gratitude as I often bear witness to that magical moment when someone else's dream or wish comes true! 99

Mindy Tsonas

exercises

THE SUPERHERO IN YOU
CREATED BY JAMIE RIDLER

"WE ALL GET TO BE HEROES MAKING A DIFFERENCE ON THIS COURAGEOUS, BEAUTIFUL, FULFILLING ADVENTURE CALLED LIFE." –JAMIE RIDLER

As a little girl, I loved stories of knights, nurses, nerds, birds, orphans, saints, dancers and horses—anyone who found their courage and became a hero by speaking their truth, facing the bully, defying the odds, standing by a friend, doing the right thing, falling down nine times and getting up ten. With each tale, my heart grew bigger and I grew braver, believing that I, too, could be a hero.

Someday.

As I grew up, I discovered there was no need to wait—that "someday" could be today or could just as easily become never. I began to understand that being a hero was a choice I could make every day, starting now.

When we choose love, courage, care or honesty, we are heroes. When we stand up for ourselves, one another, or a cause we believe in, we are heroes. We are born to be. But sometimes, in the midst of day jobs, groceries, bills and families, we forget. Here are some ways to remember:

CHOOSE MAGIC WORDS.

Every hero needs a battle cry. Pick a word or phrase that inspires you to bold action. One of my favorites is simple and straightforward: "Life is an adventure!" Choose your hero call. Say it often and say it loud. Say it whenever you need to.

CREATE YOUR POWER MOVE.

Imagine you have a secret move, one that activates your confidence and invokes your strength. Try a few possibilities. Standing tall? Hands on hips? Raising your chin? Flicking your hair? Choose what feels powerful and then practice this stance on the subway, at your desk and at the market. Use this pose whenever you need a little boost of heroic energy.

PHOTO OF JAMIE RIDLER BY JUSTIN VISSER

PICK A TALISMAN.

Choose a piece of jewelry, a symbol or a color and imbue it with power. Decide that when you wear your favorite ring, your courage expands a hundredfold; when you wear a feather, you have direct access to the power of your ancestors; when you wear red, your determination is unshakable. Don't save your talisman for special occasions. Make it part of every day.

FIND A THEME SONG.

Before heading into a big meeting or audition, before calling that cutie or your local representative, pump up the volume of your chosen tune. Let it fill you with energy and remind you from tip to toe that you are a hero fully capable of facing the challenge ahead!

Being a Force of Good starts with believing in yourself. As you step up and into your hero boots, you'll find your courage and discover that you are as magnificent as you've always dreamed you would be, probably even more so.

> 66 Being a Force of Good in the world means using my talent, ideas and energy to help, encourage and inspire others. 99
> Christine Castro Hughes

LETTER TO YOUR SMALL SELF
CREATED BY CHRISTINE MASON MILLER

**"ALL YOU NEED TO KNOW IS THIS: YOU ARE ENOUGH."
–CHRISTINE MASON MILLER**

I get a peculiar sense of delight when I lead a workshop and see the participants' eyes grow as big as saucers when I explain what we will be doing. That tiny sense of tension is a good sign—it means I'm pulling people out of their comfort zones (at least a little) and it is in that uncharted territory where all the magic happens. This is one of my favorite exercises, as it is straightforward. I've done it on my own and with groups and never gotten through it with dry eyes.

The purpose of this exercise is to spend some time being kind to your small, perhaps vulnerable, self.

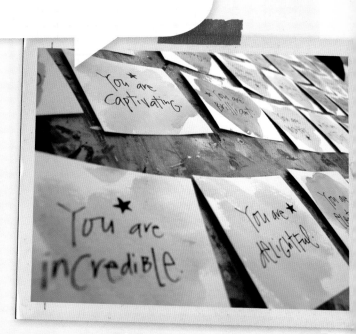

PHOTO BY CHRISTINE MASON MILLER

SUPPLIES: Two sheets of paper, pen, scissors

Begin with a blank piece of paper and a pen. Divide the page into a series of squares by drawing five lines left to right and four top to bottom, as evenly spaced as possible. Fill each square with a series of prompts that begin with "You are...." When I lead this exercise, the prompts I use are unique, beautiful, wise, charming, enough, brave, like no other, needed, a force of nature, loved, creative, powerful, a treasure, adored, feisty, spirited, strong, important, sparkly, worthy, a gift, delightful, enchanting and dazzling. Feel free to use these and/or add your own. Write one prompt in each square and then cut them into individual squares.

Turn the prompts blank side up and shuffle them around. Draw one.

Now I want you to go back to when you were small. Think about the details—what are you wearing? What is your favorite color? Where do you love to play? After a few minutes envisioning yourself and tapping into her spirit, use your prompt to write your younger self a letter. If you drew "You are brave," write a letter telling your small self all the ways she is brave. If you drew "You are worthy," explain all the ways this is true.

Here's the catch: Write this letter in your nondominant hand. That means all you right-handers will write with your left hand and vice versa.

Are your eyes as big as saucers? I hope so!

No matter which prompt you draw, the truth is that you are all of those things. If you feel inspired—and I hope you do—you can tape your prompts in tiny spaces around your home, or keep them in a box by your bed.

CONTENTS

PART I

CARPENTER'S GEOMETRY

PART II

PRACTICAL EXAMPLES

reflect

22

ARTWORK BY CHRISTEN OLIVAREZ

chapter two

the foundation

What Values Are Shaping Your Daily Choices?

❝ I hold a deep belief that each of us is here for the same reason: To be who we are. By fulfilling that simple (and challenging) task, we share the gifts we are meant to bring to the world. The arts and creativity can be key tools on this adventure because they help us both discover and express who we are. Awakening our creative impulses is the beginning of making magic in our lives and in the world. ❞

Jamie Ridler

"I AM COMPELLED TO SHARE WHAT I HAVE EXPERIENCED IN MY OWN LIFE—NAMELY, THAT SMALL SHIFTS IN PERSPECTIVE CAN MAKE A HUGE IMPACT. THIS CONCEPT GOES FOR OUR CREATIVE PROCESS AS WELL AS OUR LIVES IN GENERAL. IT'S A DAILY PRACTICE THE SAME WAY THAT BEING CREATIVE IS. HOW I CHOOSE TO LIVE AND WHAT I DESIRE TO SHARE WITH OTHERS IS INDELIBLY INTERTWINED." –TRACEY CLARK

When I began writing this chapter, I had just returned from a week on the east coast teaching. On the flight home, as I faced my first deadline for this book, I looked forward to getting back to work in my studio. While jotting notes at 30,000 feet, I felt calm, focused and confident my first chapters would be submitted on time. The following morning—back at home with clothes spilling out of my suitcase, an empty refrigerator and a big stack of unopened mail—I hit the ground running with arms flailing, feeling like there was way more on my plate than I could handle. Between raising a puppy, organizing a group show, planning for a family wedding, and getting caught up on emails, I seriously contemplated taking drastic, irrational actions, such as contacting my editor and telling her I couldn't write this book because I had too much laundry to do.

Not only was I in over my head, having decided—rather arbitrarily—that a long list of tasks simply had to be done that first day back home, I was also monumentally annoyed. I was a Writer, with a capital W, and that meant my most important, meaningful work was to write! Right?

In fact, I decided it was my only meaningful work, which meant everything else was to be regarded with disdain and rushed through as quickly as possible.

What I had temporarily forgotten was that my most important values and priorities aren't only expressed through my work as a writer, but through everything I do—even making coffee, even walking my dog. The work I needed to do to take care of my home and family wasn't separate or taking away from my work as a writer, but part of the same path. The fact that I felt cranky and overwhelmed had more to do with my choice to judge my first day back home as "less than" what I thought it should be ("I should be writing my book, not running errands!"), when really everything was beautifully interconnected and, in fact, wholly reflective of my highest priorities and values.

24

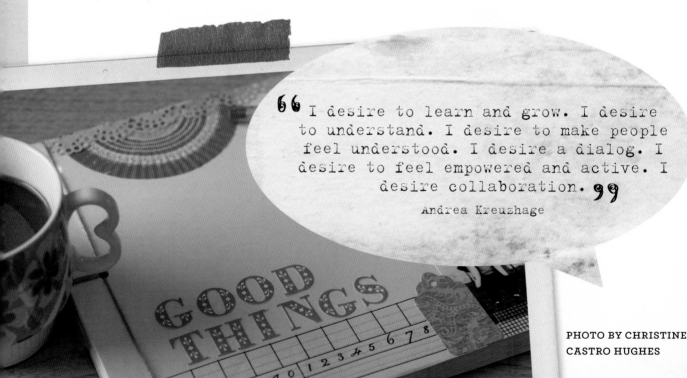

66 I desire to learn and grow. I desire to understand. I desire to make people feel understood. I desire a dialog. I desire to feel empowered and active. I desire collaboration. 99

Andrea Kreuzhage

GOOD THINGS

PHOTO BY CHRISTINE CASTRO HUGHES

"I VALUE KINDNESS AND COMPASSION, COURAGE AND HONESTY, AN UNABASHED LOVE FOR LIFE, WISDOM, HUMILITY AND GRACE. I THINK ALL OF THESE GUIDE MY DESIRE TO INSPIRE IN SOME WAY OR ANOTHER. I TRY TO STAY MINDFUL OF THEM BY HUNTING FOR BEAUTY IN THE SMALL DETAILS OF EVERY DAY, KEEPING A RECORD OF THESE IN MY JOURNAL, SHARING THEM WITH THE PEOPLE IN MY LIFE AND PRACTICING GRATITUDE." –CHRISTINE CASTRO HUGHES, ARTIST AND WRITER

In order to write this chapter, I asked the book's contributors to share their thoughts on core values and how they stay mindful of them in their daily lives. The term daily being the key, because—as I just demonstrated—even with my best effort, I still run up against my share of distractions, deadlines, worries and woes that threaten to derail my intentions. I don't know anyone who wakes up in the morning and goes to bed at night having worn the same hat all day long. My colleagues and I juggle a multitude of roles in any given week, yet we've managed to sculpt lives that reflect our strongest passions, beliefs and values. And we've done so as unique individuals, developing our own customized "tool kits" from personal stories, wild dreams and one another's examples. Vineeta Nair, artist and designer, expresses the joy of receiving such inspiration beautifully when she says, "We are each on a path to being a better person. Any help that I can get to find my way there, I take—unabashedly—with both hands spread open."

Taking the time and effort to become intimately acquainted with my core values—creativity, honesty and compassion, to name a few—was the first step in what has been a lifelong journey of creating a mindful life. Putting these values into practice in all areas of my life takes, well, practice and I am always hungry for insights and ideas on how other people do this. Developing a catalog of core values provides the foundation; creating a meaningful life from that requires daily work. Just as a home is built atop its foundation with hammers, nails and blueprints, constructing a life I love is all about using the right tools.

66 Core Values are the beliefs that form and define the center of who you are and inform how you live your life, love, work, interact, play, succeed and maybe even fail. So it follows that to define these core values—to identify and know them well—will serve you in everything you do, everywhere you go. 99
Liz Kalloch

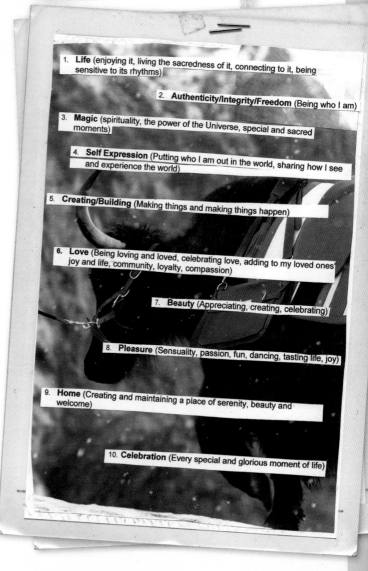

1. **Life** (enjoying it, living the sacredness of it, connecting to it, being sensitive to its rhythms)

2. **Authenticity/Integrity/Freedom** (Being who I am)

3. **Magic** (spirituality, the power of the Universe, special and sacred moments)

4. **Self Expression** (Putting who I am out in the world, sharing how I see and experience the world)

5. **Creating/Building** (Making things and making things happen)

6. **Love** (Being loving and loved, celebrating love, adding to my loved ones' joy and life, community, loyalty, compassion)

7. **Beauty** (Appreciating, creating, celebrating)

8. **Pleasure** (Sensuality, passion, fun, dancing, tasting life, joy)

9. **Home** (Creating and maintaining a place of serenity, beauty and welcome)

10. **Celebration** (Every special and glorious moment of life)

ARTWORK BY JAMIE RIDLER

> **My core values form the foundation of a life that is magnificently my own.**
> Christine Mason Miller

Soul Searching

ARTWORK BY CARMEN TORBUS

INSIDE CARMEN TORBUS'S CREATIVE TOOLBOX

Create your own support squad with positive, uplifting people who will encourage, motivate and celebrate you.

Make a commitment to spend time journaling each week; both visual journaling and freewriting can be very empowering.

Collaborate with other creatives, especially those who do something different from what you do.

Define your values and work from them.

Get a vision partner and meet regularly to brainstorm and hold each other accountable to your projects and goals.

Give yourself credit (daily!) for all you are already doing

"I KEEP MY LIST OF CORE VALUES ON A RED PIECE OF PAPER IN A SPECIAL PLACE. WHEN I AM FEELING LOST OR OFF MY TRACK, RE-VISITING THE LIST ALWAYS PUTS ME BACK TO CENTER AND REMINDS ME OF WHO I AM." –LIZ KALLOCH

Carolyn Rubenstein is a psychology graduate student, writer, author of *Perseverance: True Voices of Cancer Survivors* and founder of Carolyn's Compassionate Children—a non-profit organization that provides college scholarships to cancer survivors—which she started at the age of 14. She contributes to *The Huffington Post* and *Psychology Today* At a very young age, Carolyn established a value system that has inspired every step of her journey, whether as an author, philanthropist, student, writer or blogger. Despite a schedule filled to the brim with deadlines and obligations, she still takes the time and effort to check in with herself:

"In my home office, I pin images to a large inspiration board to remind me why I am doing what I am doing. Journaling is also an essential component of my day, allowing me to check in with my emotions and ask questions related to my core values. Finally, gratitude is a fundamental part of my life and I try to incorporate it into each day. I love sending handwritten thank-you notes and other care packages—tangible reminders that we are all capable of lifting others and inspiring change."

Carolyn's example reflects her deep commitment to what is most important to her—altruism, connectedness, contribution and authenticity. Her integrity brings to mind the compassion of Marianne Elliott, whose ideals are brought to life no matter what circumstances she is faced with.

Carmen Torbus—who describes herself as a cheerleader for creative entrepreneurs—expresses her core values as "embracing authenticity and creativity while honoring who I am," which she accomplishes through tools such as journaling, collaboration and brainstorming with a "vision partner."

Editor and creative warrior Christen Olivarez explains, "I have always had a desire to help people and encourage them to live their very best life. I believe we all have an obligation to give the best of ourselves to the world around us so others are inspired to do the same." Through regular journal writing and maintaining a daily practice of doing "one thing each day that makes (her) feel absolutely blissful," Christen honors her core values and keeps her passions alive.

Mary Anne Radmacher describes her core values as "unrelenting and profound creativity in all arenas of my life; vitality in spirit and body; consciously incorporating my intentions into all my actions; continually deepening my self-knowledge that I may form an authentic basis for inspiring and guiding others." She explains the items in her "tool kit" as "rituals" for keeping her daily life focused on what is most important to her:

"Every day I write and reach out to someone to share something that inspires me. I use timeless wisdom in a practice I call Focus Phrase, letting a phrase guide my focus and awareness throughout the day, including written reflection. I have a set of small cards with dozens of qualities that I prize in myself, or that I aspire to demonstrate in greater capacity. I draw a new card each day and display it in my studio space."

27

> **66** More than utilizing specific 'tools' to stay mindful of my values every day, my awareness of them comes up consistently when I work with my young students. They are like little mirrors, and my job is to stay present and make sure they are enjoying the process of creation. **99**
>
> McCabe Russell

PHOTO BY MCCABE RUSSELL

Jennifer Lee creates collage cards for each of her core values and draws one every day for guidance (see the Inspiration Deck mini-exercise in this chapter for instructions on how to create your own); artist and workshop leader McCabe Russell uses the example of her young students to stay mindful of honoring her own creative spirit. Penelope Dullaghan maintains a vegetarian diet and Marianne Elliott practices meditation and yoga. Pixie Campbell calls upon a sense of humor to carry her through moments when fear clouds her judgment and Kate Swoboda takes time "to breathe, to slow down, to connect with" herself. Whether it's morning rituals, focused creative projects, or simple moments of appreciating something beautiful, these artists, mothers, writers, filmmakers, wives and teachers keep their lives rooted to their values through small yet powerful acts of mindfulness.

ARTWORK BY CHRISTEN OLIVAREZ

❝ My core values help me live a life rich with meaning and fulfillment. ❞
Jennifer Lee

Make It Real

"THERE HAS ALWAYS BEEN A BENEVOLENT FORCE GUIDING ME TOWARD THE THINGS THAT BRING ME JOY. IT JUST SO HAPPENS THAT THESE ARE ALSO THE ESSENTIAL BUILDING BLOCKS THAT ALLOW ME TO CONNECT WITH MY BEST, MOST INSPIRED LIFE—CREATIVITY, COMMUNITY AND SELF-DISCOVERY, TOPPED OFF WITH A GOOD MEASURE OF HARD WORK AND INTEGRITY. THESE VALUES GROUND ME IN BOTH MY PASSION AND MY PURPOSE: TO IGNITE THIS FIRE IN OTHERS SO THEY ARE INSPIRED TO REACH FOR THEIR OWN AUTHENTIC AND MOST FULFILLING LIVES." —MINDY TSONAS

Taking the time to develop a list of clearly defined values is the first step toward creating a meaningful life. (This chapter's exercises were designed to help you get started.) These values can be used as beacons to guide you through your daily life as well as your wildest dreams. This book's contributors have shared some of their tried-and-true techniques for staying mindful of their most important priorities—practices that have enabled them to raise children, write books, build websites, travel around the world, produce films and nurture strong friendships. Creating a meaningful life isn't about following a one-size-fits-all magic formula or compartmentalizing our lives and selves into separate categories of worthiness, but about finding and developing daily habits that work with the details of your life. "Being a mom has taught me to stay mindful of releasing attachments to ideas about how things 'should be'," explains Pixie Campbell, a perspective that speaks to all the unique ways a life can be constructed and savored.

PHOTO BY MINDY TSONAS

ESTABLISHING YOUR VALUES

CREATED BY KATE SWOBODA

(Excerpted from The Courageous Year: Level One *e-book)*

"I USE A NUMBER OF TOOLS TO STAY CONNECTED TO MYSELF, WHICH IS WHERE I BELIEVE IT ALL STARTS."–KATE SWOBODA

"Who am I?" is such a big question with more than a one-word answer. The purpose of this exercise is to determine your personal values—the characteristics that are unique to you and make up who you are.

PRACTICE 1

Create one blank journal page with each category listed below as a header:

- Friends and Family
- Intimate Relationships
- Money
- Health
- Physical Surroundings
- Career
- Fun and Recreation
- Personal Growth

Take five minutes for each category and write down all the words and qualities that come to mind for each category. You might notice some repeats among categories.

PHOTOS BY KATE SWOBODA

PRACTICE 2

Take a look at all of the descriptors you wrote down for each category and note which words came up repeatedly and/or resonate the strongest for you. Write these words on a new journal page. This is your Values List.

Narrow this list down to 10 Core Values.

PRACTICE 3

From this list of Core Values, dig deeper with the following questions:

What values am I most likely to sell out on?

Under what circumstances does this happen?

In what areas of my life do I feel I am living in greatest alignment with my values?

The important thing to notice here is that in the situations where we are happiest, our personal values will be present. Knowing your values opens the door to make powerful changes that matter. For instance, even if you are unhappy with your job, you can find ways to bring your personal values into the workplace. Knowing your values is a powerful tool.

MINI-EXERCISE: MAKE YOUR OWN INSPIRATION DECK

BY CHRISTINE MASON MILLER

I created a series of small collages a few years ago to celebrate my most important values and I still keep them in a bowl on my desk for inspiration.

SUPPLIES: Index cards, magazines for imagery, glue stick, scissors

The collage formula for this project was very simple: one image for the background, one or two images for the focal point and one word or phrase. Collect words that inspire you, and then find images to go with them. Before you know it, you'll have a deck of 52 cards.

DRAINS MY SOUL / FEEDS MY SOUL
CREATED BY PENELOPE DULLAGHAN

"MY CORE VALUES CAN EASILY BE SEEN AS TOOLS OR TECHNIQUES, BUT TO ME THEY JUST FEEL LIKE THE DETAILS OF MY LIFE." –PENELOPE DULLAGHAN

Creating a mood board is a great exercise to determine what ideals are shaping your daily choices and whether or not they line up with your core values. It can be created in many ways, using visual elements or a written list, but I've found this exercise most effective when I use words and pictures together.

SUPPLIES: Two large pieces of paper or poster boards, pen or marker, magazines (for collage images), scissors, glue stick

Set your two pieces of paper on a table. Write "Drains My Soul" on one sheet and "Feeds My Soul" on the other.

On the "Drains My Soul" page, write words that represent objects, places or situations that make you feel miserable, tired or drained. Items on my list include traffic jams, brightly lit convenience stores, malls, high heels, bars and cell phones. From your magazines, gather images that drain you when you look at them and glue them onto the paper around the words. By the time this is finished, you're probably feeling pretty dumpy. Time to move on to what feeds your soul!

On the "Feeds My Soul" paper, write words and paste pictures of things that make your heart sing. It could be swatches of your favorite color, pictures of your friends, a hammock, yoga, even brightly lit convenience stores—whatever makes you happy. My list includes hiking on a snowy path, thrift-store shopping, reading on my porch and watching movies at home with my husband.

Over the course of a week, keep adding to your board. Paste magazine cutouts, a pretty leaf, torn wrappers, an e-mail from a friend. Continue to write words that pop into your mind for each category. After a week you'll have two finished boards.

Look at the "Drains My Soul" board and observe how it makes you feel—does it bring you down? Is it hard to stand up straight? Are you suddenly tired and agitated?

Next focus on your "Feeds My Soul" board. Notice how your mood changes again. Are you standing taller? Feeling energetic? Do you feel your heart shining?

Now visualize your daily activities. Which board does your typical day resemble? See if what you do with your time matches up (mostly) with what feeds your soul. If you find an activity that drains you, start looking at how you can change that.

For example, let's say your "Feeds My Soul" board has images of fresh food or chopped vegetables, but when you hold up your daily activities you see that you go out for fast food three times a week. That's good—that's a discovery. Now we know one thing that may be draining your joy. See if you can change that in a small way. Maybe just go out twice a week. Take baby steps toward aligning more with your values of health and joy.

As your steps continue, you can refer back to your boards and even add to them in the process. Check in now and then to see how the life you're leading fits with the life that feeds your soul.

IMAGINE

THE
POSSIBILITIES

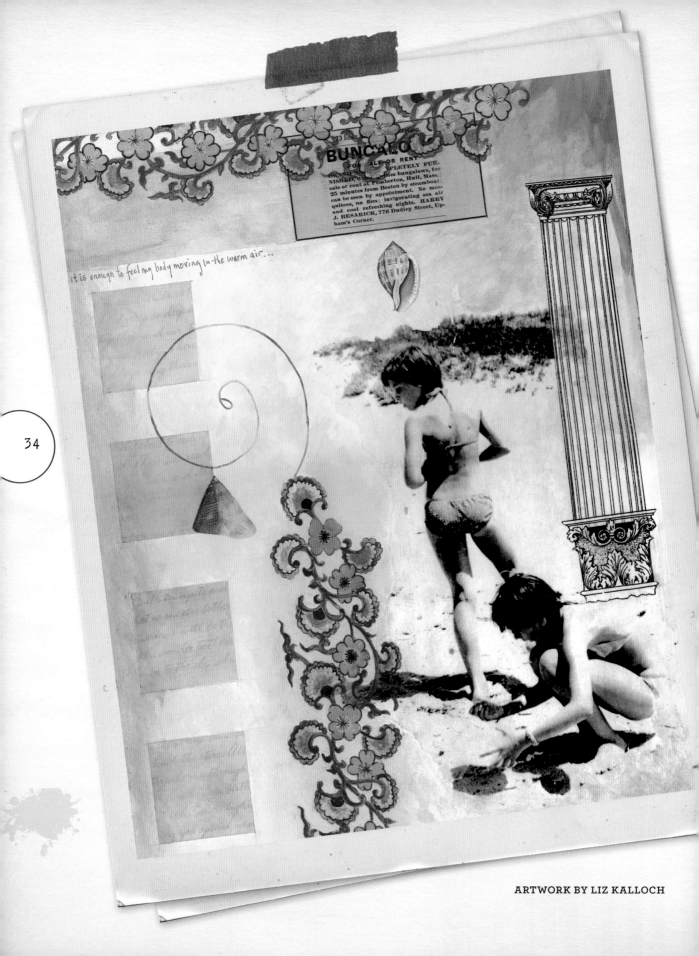

ARTWORK BY LIZ KALLOCH

chapter three

walking hand in hand

The Partnership Between You and Your Dream

> **"** Your dreams call you out. They ask you to become more than you thought you could be. **"**
>
> Jamie Ridler

"DREAM BIG. THEN DREAM BIGGER." —CHRISTINE CASTRO HUGHES

The first steps I took as a bona fide professional Artist were out of Santa Barbara City Hall in the fall of 1995, where I had just secured my business license for a company called Swirly. I'd already mapped out my long-term vision for this venture—to become a licensed, global brand that inspired others to follow their dreams—but had no specific plans for how to get there. The ensuing months, which took Swirly from small retail gift catalog to wholesale greeting card line, did not proceed along an orderly, linear path, but were a series of opportunities, missteps and disasters that tested my resolve, adaptability and commitment to the dream I had so passionately constructed.

To put it more plainly: I made it up as I went along.

The business grew steadily over the next 18 months, expanding across the country from a 100-square-foot home office—every card printed to order, each one handmade. As I celebrated Swirly's two-year anniversary to the steady, 8-hours-a-day hum of four ink-jet printers, I knew I'd reached a crossroads: I could maintain my current level of sales—staying well within my comfort zone—or take a risk that would give Swirly the opportunity to take her greatest leap yet. If I wanted to stay true to my vision, I would have to invest in inventory. With a card line that now offered 88 designs, and a cost-effective print run requiring 1000 of each, this move would require a new system of fulfillment, storage space, and a bank loan, not to mention an unwavering belief in my dream.

When I shared the news of this decision with a long-term design client, they immediately expressed interest in placing an order for the new cards. Thus began a steady back and forth for the next many weeks—I'd update them on the coordination of an 88,000 card run, and they kept me informed about the status of their order. The week of the press run arrived, and then I received the call.

ARTWORK BY CHRISTINE MASON MILLER

"Hi Christine, we're ready to place our order."

"OK, great," pen in hand, order form ready.

"We would like 5000 each of the following designs..."

Blink. Blink. Pen is set down.

"Excuse me?"

"Yes, 5000 each of the following designs..."

"I'm sorry, I'm going to have to call you right back."

Next call: "Hi David (my sales rep), stop the presses. This order just got bigger. A lot bigger."

In that moment I became acutely aware that my dream had been there all along, guiding me through every step, even the ones I thought were pernicious. While I might have had an inkling of this before that fateful phone call, it had yet to sink deep into my bones, to become the Truth of following my ambitions. This client's order amounted to double what I borrowed from my bank. I paid off my loan, paid off my car, expanded my line, and printed a new catalog. More importantly, I felt the undeniable presence of my dream, an experience that has influenced every aspiration I've pursued since.

These days, my first steps toward any endeavor are taken with a unique kind of awareness—the anticipation of when, where and how my dream is going to boldly make herself known. Once I set sail and get to work, I know it is only a matter of time before I'm given a sign—a chance encounter, a contract, or even just an email—that lets me know my dream is steering the ship. After that, my job is to keep doing my best work; the bond with my dream is a marriage of sorts, requiring my continued, focused commitment.

Director Andrea Kreuzhage speaks to this experience when she discusses the editing process for the *1000 Journals* film. "I had 165 hours of footage that needed to be cut into a ninety minute film. Each time I sat down to do this work I always asked the same questions: Is the film speaking to me? What is

PHOTO BY MINDY TSONAS

it saying?" She knew she was not alone as this dream came to life. The film itself was her partner; the work she put into it was its own sustained reward.

The beauty of having this level of trust with my dreams is that the burden of bringing them to life isn't entirely on me. I don't have to plan every single detail, I don't have to know everything ahead of time. For any part of the venture I do map out, I don't need to panic if something changes, shifts or veers off in a different direction. I can fall back on a soft nest of Trust, knowing my dream is providing exactly what I need, and move through the twists and turns gracefully. The adventure of following a dream isn't about controlling, wrangling, and wrestling a million tiny details into a "perfect", pre-planned form; it is about setting an intention, having a vision, and being as open as possible to all the ways that vision might take shape.

PHOTO OF ANDREA KREUZHAGE (L)
FROM THE FILM *1000 JOURNALS*

"WISHSTUDIO—THE VIRTUAL CREATIVE LIFESTYLE STUDIO I LAUNCHED IN 2010—HAS ALWAYS BEEN INSIDE OF ME WAITING TO COME OUT. THIS I BELIEVE WITH ABSOLUTE CERTAINTY. EVERY EXPERIENCE, JOB AND BIT OF LIFE AND LEARNING BROUGHT ME TO A PLACE OF BEING ABLE TO CREATE AND OFFER WHAT I DO IN THE WISHSTUDIO. I WOULD NOT HAVE BEEN ABLE TO CREATE IT ANY SOONER OR BETTER AT ANY OTHER TIME THAN WHEN I DID. THERE IS TREMENDOUS COMFORT IN KNOWING THIS—THAT I DID NOT SQUANDER MY TIME, MAKE THE WRONG CHOICES, OR GO ASTRAY. ALL OF IT WAS A PART OF THE CREATION, A PROCESS WHERE MY DREAM KNEW THE TRAJECTORY AND GUIDED ME ALL ALONG." –MINDY TSONAS

I experienced this the day I received an order that almost made me fall out of my chair and countless times since. Even the creation of this book has been a process of letting the book reveal itself versus chiseling out a carefully detailed blueprint of what I think it ought to look like. Carolyn Rubenstein shares a similar approach when she says, "While part of me craves structure, routines, labels, and definitions, there is another part of me that wants to venture beyond the known, the safe—the cozy comfort zone. For it is when I venture off into side roads and uncharted territory that I can discover and create in ways that would not be possible if I stayed solely on cruise control."

The book you are reading now is the work of the book—it is the thoughts, ideas, energy, circumstances and other impossible-to-predict turns of events that I chose to follow during a specific period of time. I am writing this chapter in this moment because the dream gave me a gentle nudge to write right now. I am sitting in my kitchen on a Tuesday morning with dirty dishes in the sink and an appointment in an hour. Why here? Why now? In this moment, those questions need not be answered; right now, my work is to follow the nudge, whether or not the details of this urging are what I think they should be. I might have ideas about being inspired to write only when I've lit a certain candle and have hours of uninterrupted time, but my dreams are not always especially interested in accommodating these fuzzy-edged imaginings (and neither is my editor). In fact, dreams tend to infiltrate all kinds of unexpected situations in order to garner attention.

> ❝ The jump is so frightening between where I am and where I long to be—because of all I may become I will close my eyes and leap. ❞
> Mary Anne Radmacher

THE OTHER SIDE OF LETTING GO

BY MINDY TSONAS

Today, just now, I let go of something really big. This seems to be an important theme for me right now, this letting go—letting go of expectations and letting go of things I know just aren't right for me in this moment.

Admittedly, I am not very good about saying no to bright, shiny things. Well, not so much things, but opportunities and possibilities. I am lucky to have so many swirling around me at any given moment and want to capture them all with my big pink butterfly net, especially the biggest and sparkliest ones, like the one that zoomed across my sky this week.

Out of the blue, I was offered an amazing commercial space in the lovely downtown area near my home. The space was amazing, the price was right, the possibilities endless and the temptation enormous! So big that up until this morning I was one step away from signing on the dotted line. Honestly, though, I was torn. After leaping at the possibilities with my heart all aflutter, an annoying nudge kept saying "You are not ready. It is not time." I kept trying to ignore it, but then I did something radical: I let go of the space.

In the past I have rationalized my way into some of these so-called opportunities by saying things like it's "meant to be" or "a once in a lifetime opportunity," when really the universe is trying to teach me a valuable lesson that I've never really understood until now. I always thought the doubt was just fear to proceed. I know I can be fearless, but I also know I can be foolish.

So this time, I chose to stay with what is right in front of me. I'm accepting my life just as it is—perfect and blossoming from where I sit in this moment. That nudge—the conflicted feeling I had—was my inner GPS saying, "Don't do it." So I trusted that voice and on the other side of letting go, I feel free.

Excerpt from www.mindysblog.wishstudio. com, October 2, 2010.

ARTWORK BY PENELOPE DULLAGHAN

"BEING A CHEERLEADER GAVE ME WHAT FELT LIKE SUPERPOWERS. I COULD LET GO OF INSECURITIES AND TOSS INHIBITION ASIDE THE SAME WAY I FLUNG OFF MY STREET CLOTHES WHEN I SUITED UP BEFORE A GAME. MY CHEERLEADING UNIFORM WAS MY SUPER-SUIT. IT GAVE ME COURAGE. IT GAVE ME THE STRENGTH TO BELIEVE IN MYSELF." –CARMEN TORBUS

When Carmen Torbus was eighteen years old, she stood on the precipice of making a lifelong dream come true. After dressing up as a cheerleader for Halloween and getting voted Most Spirited of her high school class, she was awarded a cheerleading scholarship. "I wanted more than anything to be a professional cheerleader. I didn't ever want it to end," Carmen explains. After practicing her stunts, perfecting her cheers, and securing a spot on her university's cheering squad—with a full scholarship to boot—she understood that her dream had marched right up to her and said, "Let's go." Her reaction: She walked away. Carmen turned down her scholarship and enlisted in the Marine Corps.

No matter, her dream stayed with her.

Carmen elaborates: "Funny how heart voices work. They don't just talk to you, they find alternate routes that lead you where they want you. And they will keep talking and tugging at you, even if you ignore them. Sometimes the decisions you make will take you down a difficult path with difficult lessons, but if you can sit still enough—and quiet the voices in your head—you will hear the voice in your heart. It is always there; you just need to listen." Although this wasn't apparent to her at the time, now that Carmen has fully embraced and developed her role as a professional coach and cheerleader, she sees clearly how her cheerleading dream was able to weave itself into an array of different environments, even the United States Marine Corps. She led drills, trained new recruits and created Marine Corps cheers. "My heart voice was guiding me, I just didn't recognize it at the time," Carmen says.

After Carmen finished four years of service, no matter what type of job she had, the cheerleader in her continued to take center stage. "I got jobs that always put me in training roles—in front of groups needing support, encouragement and direction. I didn't realize that cheerleading was exactly what I was doing," Carmen says, "And that it was what I had been doing all along." Today Carmen is not at all shy about her passion for cheerleading, having developed her own "C4" approach to inspiration: Cheerleading, Coaching, Consulting, and Conspiring. Whether in the Marine Corps, a corporate environment, or as a blogger, her passion has risen to the surface, showing Carmen and those around her what's possible when we choose to believe in ourselves.

ARTWORK AND PHOTO BY CARMEN TORBUS

Make It Real

"WE ALL HAVE OUR OWN WORDS TO SHARE, OUR OWN STORIES TO TELL, OUR OWN VIEWPOINT ON THE WORLD, AND SOMETIMES IT TAKES DIGGING DEEPLY TO FIND THOSE STORIES AND IDEAS. THE GOOD NEWS IS THAT WE ARE NOT ALONE ON THESE EXPEDITIONS. OUR DREAMS ARE RIGHT THERE WITH US—GUIDING US, TEACHING US, LIGHTING THE WAY." –LIZ KALLOCH

Embarking on a new project, dream or journey is an experience akin to giving birth. A seed is planted, the idea is nurtured—by doing research, creating a space, preparing supplies—and then on a day that may or may not be expected, the dream is born. Maybe this birth occurs once a business license is secured, the day a website launches, or when the first stroke of color is swept across a canvas. No matter what circumstance marks that point of liftoff, it is a moment pregnant with astounding possibility.

The instant you acknowledge your dream and begin to build its foundation, you have a partner. Even in situations that might appear to be too constricted for certain passions, they will find a way in. You can dial your intuition directly to her voice no matter where you are, and trust she will make herself known to you in unexpected, delightful ways. Your job is simply to do your best work. She wants to reward your efforts and honor your commitment. She wants you to succeed. She is your unmitigated cheerleader.

> 66 Who would have thought you might find a cheerleader deep inside a United States Marine, decked out in combat boots and camouflage utilities? 99
>
> Carmen Torbus

66 I nurture the seeds of my Dreams tenderly as I know that my faithful and unwavering practice will eventually lead to a harvest.
There is nothing I can do to speed the process, so instead—as I hold in my heart excitement for the fruition of my Dreams, as my mouth waters in anticipation of the juicy adventures that are the horizon—I will prepare.
I will ready my heart and soul.
I will wash the dishes and do the laundry.
I will take the time to tidy my home honoring what is to come.
I will wake each morning to my watering can and tend to my Dreams, but I will not rush them.
And I certainly will not doubt them.
I will be patient and approach each day knowing that I don't have much time until my Dreams are ripe on the vine.
I want to be ready for the harvest; to have much of the work out of the way so that when my Dreams are ready, I will be too. 99

Tracey Clark

42

> **"** Every morning, my dream takes my hand and guides me. Every evening, we look at each other and renew, refresh and update our bond. **"**
> Andrea Kreuzhage

PHOTOS BY TRACEY CLARK

exercises

THE PASSION EXERCISE
CREATED BY ANDREA KREUZHAGE

**"FOR ME, THE INSPIRING SPARK USUALLY STARTS WITH CURIOSITY: WHAT IS THIS ABOUT? HOW DID THIS START? HOW FAR COULD THIS TRAVEL? INSPIRATION AND A SENSE OF DISCOVERY OFTEN GO HAND IN HAND."
–ANDREA KREUZHAGE**

Pick one of your passions—the one that needs the most nourishment (we all have one that is starving for attention). For this exercise, you are an analyst and researcher; your tools are pen and paper.

DIAGNOSIS
First, diagnose this undernourished passion: Why is she so small? Is she a secret passion? If yes, why? Are you afraid she may change your life? How long has she been with you? Do you remember where she came from? Look closely and take notes.

QUESTIONS
Next, talk to her. Ask your passion what it would take for her to grow. How much of your time? How much money to get started? What kind of changes in your house? If there were no limits, what would she ask for? What are her goals? Allow her to grow and expand in whatever directions she wants; give her full reign.

REALITY CHECK
Now step back. Is this passion real, or is it a fantasy? Dare to test her roots. Is she grounded in your reality? Can she participate in your actual, day-to-day life? Can you start to make space for her? Passions can be like family members or passionate affairs, maybe even flings. They can grow from within your life or require you to drop everything else. It is important to find this out because it will determine the nature of your partnership.

FINDING THE SPACE
In your mind, play out both scenarios:

Your passion takes over, replacing most of what is in your life right now.

Your passion is integrated into your life, finding its spot in your day-to-day.

Which scenario is most appropriate and satisfying? Some passions cannot grow unless they have center stage and your full attention, but there are other priorities to consider. The key is to find the right balance.

PASSIONS CAN BE DISTRACTIONS
In all of these steps, be honest and realistic, keeping in mind that passions can be distractions—escape hatches—and you may need to look at the quality of your current life as well. Is something missing?

PASSION SCHEDULE
As you get to know your passion and her ambitions, create a passion schedule. Start with next week, using today and the following days for preparation and planning. However much time you can afford to dedicate to your passion, pencil it in. Maybe it's only an hour in the first week, or an hour a day, or one full day. Whatever it is—make that commitment to yourself.

Make a detailed plan for how you want to spend this time with your passion. She is a new part of your life, so treat her like a baby by taking baby steps: Set attainable goals; allow for research and the learning of new skills; get to know new people and communities.

GROWTH AND PROGRESS IS A PROCESS
Depending on your passion's size and scope, she may require increasing amounts of time. Something else will have to be dropped to make space for her. When you look at your schedule for the following weeks, keep adjusting.

THE PARTNERSHIP
Talk often to your passion. In fact, make talk time part of your schedule. Ask her: Are you happy? Satisfied? Is anything missing? What could be better? Should we experiment and try something new? Don't be afraid of setbacks and stay open to surprises and discoveries. Whether with people or passions, partnerships involve constant communication, negotiations and compromises.

44

❝ Be who you are, learn to know yourself deeply and truly and trust yourself intuitively and completely. ❞

Liz Kalloch

PHOTO BY CHRISTINE MASON MILLER

THE PERFECT TIME IS NOW
CREATED BY CHRISTINE MASON MILLER

"AT ANY GIVEN MOMENT, YOU HAVE THE POWER TO BEGIN YOUR NEXT ADVENTURE." –CHRISTINE MASON MILLER

The purpose of this brief, two-step exercise is to remove blocks that may be preventing you from taking the first steps toward a project, dream or spark of inspiration. Let's begin!

SUPPLIES: Journal, pen

PART 1 : I SHOULD

STEP ONE: Write down a dream, idea or project you have been wanting to pursue but have not started.

STEP TWO: Pretend you have one month to prepare. Make a list of everything you believe you need to do in that one-month period before you can begin this project. Include everything that comes to mind—even laundry!

STEP THREE: Now pretend you only have one week. Cross any items off the list that are not your top priorities.

STEP FOUR: Now you only have one day! Cross more off your list!

PART 2: I WILL

STEP ONE: From your one-day list, choose one item (it can be as simple as "brainstorm story ideas for five minutes"). Make a commitment to yourself to accomplish that task within the next 48 hours.

STEP TWO: Write the following in your journal, with your signature and today's date:

"I, {your name}, hereby commit to {your task} within the next 48 hours, the first step toward {your dream}. The time to begin is NOW!"

ARTWORK BY CHRISTINE CASTRO HUGHES

chapter four

mentors, guides and beacons of light

Our Work as Students, Our Gift as Teachers

66 Rather than desire, I dare to inspire, but before I can do anything that might inspire others, I have received the gift of inspiration myself. To inspire may very well be a dialog—a two way street—an organic process rooted in exchange. 99

Andrea Kreuzhage

"YOU NEVER KNOW WHEN, JUST BY BEING YOURSELF, YOU'LL BE SOMEONE ELSE'S GIFT."
–KATE SWOBODA

Balance is one of those words that always triggers resistance in me, particularly in conversations about how to find it, create it and keep it. I have been wary of this approach to finding contentment in life because it has the potential to make me feel like I am not enough. If I look at my life as a pie chart, it won't be adequate to have my "Satisfaction With Work" slice filled in; I must also have hefty servings of "Family Connections," "Exercise" and whatever other items are supposed to be my most important priorities, and everything must be in *balance*. This is a nice idea on the surface, but I rarely find it especially useful, because all it takes is one unexpected fork in the road—or, as I'm know

experiencing, one puppy named Tilda—to throw everything out of whack and completely off-kilter. In one quick instant, my lovely little pie has fallen upside down on the floor, all those tidy individual slices a giant, messy, impossible-to-pull-apart pile.

It is in those moments—when I feel like balance wants nothing to do with me because I've somehow failed to charm her—that I think of a woman named Dolores Forcino. Dolores was one of my first card reps and my mentor. Not only did she instruct and guide me through all the ins and outs of running a wholesale card business ("This is what you include on an invoice. This is how to package your cards."), she also shared an insight that I've held on to for the last fifteen years, words that inspire a deep exhale whenever I feel like my pie is a great big blobby failure.

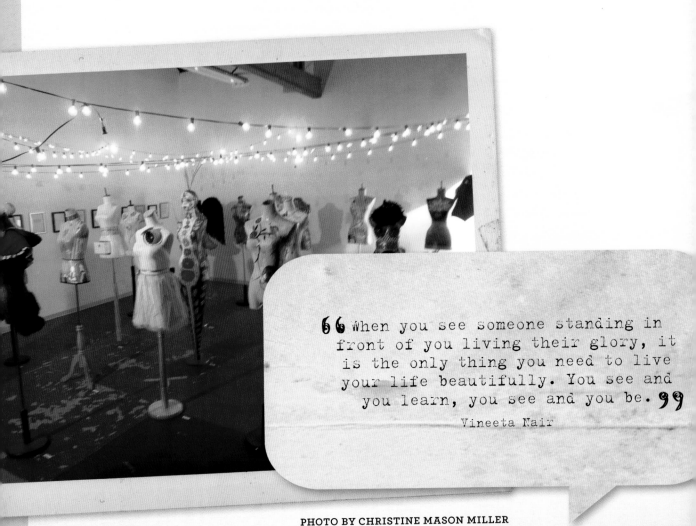

66 When you see someone standing in front of you living their glory, it is the only thing you need to live your life beautifully. You see and you learn, you see and you be. 99

Vineeta Nair

PHOTO BY CHRISTINE MASON MILLER

ARTWORK BY PENELOPE DULLAGHAN

49

After discussing things like card sales and package design, our conversations usually veered off in any number of directions and topics, from marriage to travel to current events. It was during one of these phone calls, in an exchange about trying to create a balanced life, when Dolores shared her matter-of-fact, experienced-enough-to-know perspective on the subject: "You'll never get there, so you can let that go." While this statement looks negative and blunt in the static black-and-white of this page, her expression of it was far different. Her intention was not to be discouraging, but to free me from a pursuit that she knew from experience was not an essential—or even especially practical—component of a full, meaningful, and, yes, balanced life.

What Dolores taught me in that conversation and countless others is that life is not a pie chart to be managed with percentage points, but an impossible-to-predict interplay between my dreams, values, obligations, responsibilities, and relationships. Dolores was my mentor not only as a greeting card business owner, but also as a woman who had yet to turn thirty, still contemplating all the possibilities life might have in store for me. She inspired me not with detailed instructions on how to live a meaningful life, but by teaching me the value of letting certain ideals go. Her earnest appraisal of "balance" burst through the receiver of my phone and found a permanent home in my psyche, an insight I turn to again and again.

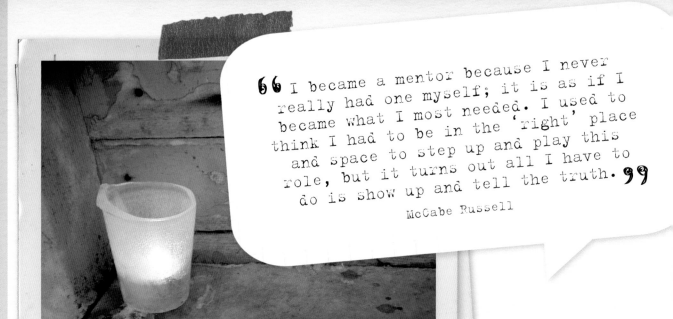

> **I became a mentor because I never really had one myself; it is as if I became what I most needed. I used to think I had to be in the 'right' place and space to step up and play this role, but it turns out all I have to do is show up and tell the truth.**
> McCabe Russell

PHOTO BY JAMIE RIDLER

"WHILE I DIG AND BELIEVE IN THE APPRENTICE/MENTOR MODEL, I KNOW THAT IT'S NOT ALWAYS SO EASY TO FIND AND SECURE AN ACTUAL MENTOR. MENTORS SEEM TO 'APPEAR' WHEN THEY WILL. SO WITH THAT IN MIND, I'D LIKE TO SAY THAT I ALSO BELIEVE STRONGLY IN THE POWER OF WHAT I WILL CALL A 'COM-MENTOR'—SOMEONE WHO REALLY GETS YOU, YOUR WORK AND YOUR SENSIBILITY AND WHOSE OPINION YOU DEEPLY VALUE. WHEN THAT PERSON COMMENTS ON YOUR WORK OR WORK IN PROGRESS, IT IS A GOLDEN KIND OF INPUT: HONEST, ASTUTE AND HELPFUL IN TERMS OF YOUR PARTICULAR VISION." –AMY KROUSE ROSENTHAL

A February 2011 search on Amazon.com brought up more than 123,000 titles under "self-help" and 112,000 for "inspirational." There were 1.6 million results for a Google search of "motivational speakers" and more than 3.3 million for "inspirational quotes." Inspiration and examples of how to bring more of it into our lives are everywhere—a mouse click, book purchase or lecture away—with hoards of individuals stepping forward with formulas, answers and examples of how to create the most passionate, meaningful life possible. I have taken advantage of such resources throughout my life—I've wept during a poetry reading with Mary Oliver, read *The Four Agreements* by Miguel Angel Ruiz, and stood in line to have a book signed by Marianne Williamson.

These paragons of living a passionate life have been meaningful sources of inspiration for me, but the examples I am most grateful for are much closer to home and less about straightforward teaching than learning through osmosis—in conversations over coffee, long talks on the phone, and even long stretches of silence. I think of Dolores's spot-on perspectives; my grandma's wise example; and Alan Glick, my college mentor, who fostered my leadership skills with kindness, equanimity and a wicked sense of humor, not to mention a willingness to let me hang around his office for hours on end, always eager

for our laughter-fuelled exchanges. Earlier on, my high school journalism teacher Sue Kulesher entrusted me as an editor of our school paper when I was only a sophomore, handing me a pair of shoes that felt too big for my fifteen-year old self, but that I eventually grew into with her trust, support and influence.

In other words, while there is plenty of inspiration and guidance available to me from places that are many steps removed from my day-to-day life (I don't have coffee dates with Anne Lamott), my most impactful mentor relationships have always existed right in my backyard. An impromptu online survey taken for this chapter told a similar story—83 percent of responses to the prompt "Name one person who has been a beacon of light for you" named personal relationships. Respondents shared stories of godmothers, aunts, spouses and sisters. Amy Krouse Rosenthal pointed to her daughter, Carolyn Rubenstein talked about her husband and Christine Castro Hughes named her grandma. Pixie Campbell reminisced about her great-great Granny Robertson.

I look to artists and writers like Robert Rauschenberg and May Sarton when I need inspiration, but it is the examples of friends, family and colleagues that make the deepest imprint—examples that inspire, teach and guide me as I forge my own path toward a meaningful life. On the flip side, I have learned to be especially mindful of my own example, aware that my actions and choices have an impact. Even if I am not serving as someone's mentor in an official capacity, I still aim to set a positive example that is uplifting to those around me.

51

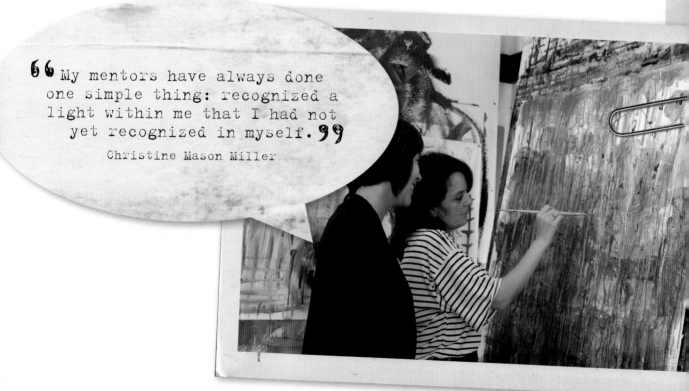

66 My mentors have always done one simple thing: recognized a light within me that I had not yet recognized in myself. 99
Christine Mason Miller

PHOTO OF JENNIFER LEE (L) BY KRISTEN MORSE

ARTISTIC INFLUENCE
BY CHRISTEN OLIVAREZ

I deal with artists on an almost hourly basis and have to admit there are times when I think to myself, "What gives me the right to show their art? Who am I to be curating, selecting and editing work for a big time magazine?" And then I look at my family and the women who helped me get here.

Like many of you, I grew up with a crafty mother, who happened to have her own crafty mother. Whenever it could be made, my mom would put her nose to the sewing machine, so to speak. Sewing, quilting, cake decorating, scrapbooking—you name it, it surrounded me. Some of my fondest memories are of sorting through my mom's supplies, like her tin of vintage buttons given to her by her grandmother, my dear, sweet great-grandmother Neva, whose affinity toward owls I've seemed to inherit. I remember waiting anxiously for my mom to come back from her quilting classes with fabric swaps in tow. I would sort each square by color, cherishing each pattern and learning how they spoke about the person who picked them.

My aunt is also a professional artist and I remember being completely drawn to her Magic Markers at a very young age. Given that they were the finest she could buy at the time—Prismacolor—I coveted them. Many nights were spent flipping through her clip art books, eyeballing vintage images and wishing I could put my thumbprint on the art world the way she did.

My life has always revolved around art. For every occasion, I begged for the latest art kit—from stickers to beads to pottery wheels. If it was artsy or craftsy, I just had to have it. I've never left a surface un-doodled, never left a fiber untouched. This has always been a part of me. And I sincerely hope that it makes me worthy of working with other people's art, because I cherish that opportunity with all of my heart.

Excerpt from thedeliberatelife.typepad.com, July 25, 2009.

"My mother is an amazing artist and our art-making is something strong we've always had in common. She has always encouraged my creative endeavors; she is always in my corner. When my doubt sets in, she reminds me of a picture I drew when I was small. It was of a worm on a tire swing. She tells me that this is who I've always been and I always believe her. No matter what, she helps to get me back on track."

Anne Carmack

"IT IS IMPORTANT TO SEEK OUT A VARIETY OF MENTORS FOR DIFFERENT ASPECTS OF YOUR WORK AND LIFE. YOU'LL LEARN DIFFERENT THINGS FROM EACH ONE AND DEVELOP YOUR OWN MIX OF WHAT WORKS FOR YOU." –JENNIFER LEE

These days, mentor relationships can also be initiated and created with nothing more than the click of a mouse. Jennifer Lee elaborates: "I happened to find one of my mentors, Chris Zydel, on Twitter. I did a search on 'expressive arts' and, to my surprise, discovered her studio was less than ten minutes from my house! I started to take intuitive painting classes with her and then, because I was learning so much about myself through the work, decided to take her Expressive Arts Teacher Training program. As a mentor, Chris shared her wisdom and experience and helped me develop my own skills as a leader through coaching and feedback. That brought more compassion and care into my own role as a mentor, expressive arts facilitator and coach." Jennifer finds support and inspiration from a number of friends, teachers and guides and channels these insights and lessons into her own role as a leader and mentor. As Andrea Kreuzhage says, "We are all teachers. And we're all students." We learn, we grow, we teach, we inspire.

Tracey Clark found her most life-changing mentor with her first professional photography job:

"For my first interview, my mentor-to-be asked to see my portfolio. I didn't really have one, as I was nearing the end of my last semester of college, but gathered together some artwork and photos. As he looked through my work he not only offered positive feedback, but also a job! It meant so much to me, coming from a near stranger and someone whose work I admired so much. He agreed to teach me all the technical aspects of photography as long I promised to keep doing what I was doing. He said that anyone could learn to use a camera, but not everyone has an innate ability to capture what matters. Through his encouragement, kindness and patience, he taught me everything I needed to become a professional photographer. In other words, he changed my entire life."

Just as my high school journalism teacher saw something in me that I had yet to recognize, Tracey's mentor helped her see, appreciate and nurture her own talent. His knowledge and experience gave her more than instructions on "all the technical aspects of photography"; his encouragement and belief in her abilities placed her squarely on the path toward the life she is living now as the founder of the collaborative photo blog *Shutter Sisters,* and author of *Expressive Photography: A Shutter Sisters Guide to Shooting from the Heart,* just two of the many photography projects that have inspired budding photographers all over the world.

66 If you have one friend, you hold the hand of the world. **99**

Mary Anne Radmacher

PHOTO BY TRACEY CLARK

AN UNEXPECTED MENTOR

BY LIZ KALLOCH

One of my most powerful mentor experiences happened eighteen years ago, when I was starting to move back into painting but felt hesitant, nervous about pulling out my brushes after a four-year hiatus. The mentor that came along was not a painter, but a dancer and the timing and synchronicity were pure magic.

We shared many discussions about pushing through creative blocks, but it was watching her dance that unlocked the door I was standing behind with my painting. I spent a few afternoons in her studio while she was choreographing a piece, watching her hit wall after wall of frustration, doubt, exhaustion and judgment. Each time she would stop, gather her breath and energy and then literally push and kick through whatever metaphorical wall was holding her back. And then she'd start again.

I took her physical practice into the painting studio with me and I still use it. When I hit a moment of self-doubt, I stand with my palms together in front of my solar plexus, inhale deeply and then quickly push my arms out in front of me while exhaling deeply. I repeat as necessary and I repeat it a lot! Physical movement—versus intellectualizing—is a sure route out of my head and back into my creative work. This is what my mentor taught me. The physicality of her art form was just what I needed to take me out of my processing stance and into a more active and energizing approach, an example I'll never forget.

Make It Real

Just as our dreams provide support and guidance as we forge a path toward their fruition, mentors provide wisdom, insights and examples that can push us farther than we might believe we are capable. Whether a teacher, family member, or sought-after tutor, these inspiring figures can lure us into uncharted territory where we just might find what we need to become mentors ourselves. Figuring out how to create our most meaningful lives not only requires passion and commitment, but also inspiring examples to learn from, follow and celebrate. Then one day, perhaps without our even realizing it, we become an example for others on their own inspiring journeys.

66 There is nothing I love more than hearing, 'I'm so inspired right now!' and if there is anything I can do to cheer you on to personal victory, I'm all over it! 99

Carmen Torbus,
on being a mentor

WORDS OF WISDOM AND GRATITUDE
CREATED BY CHRISTINE CASTRO HUGHES

"IT'S ALL ABOUT THE LITTLE THINGS; THE LITTLE THINGS MEAN A LOT." –CHRISTINE CASTRO HUGHES

Very often, we make an impact on others without even realizing it, just by sharing an encouraging word or piece of advice. This exercise is about commemorating those who have made a difference in our lives and making a difference of our own in a simple but powerful way.

In the first part of this exercise, you will collect words of wisdom from your mentors and heroes and create a visual record that you can turn to when you need a dose of inspiration. Afterward, you will return the favor to one of those heralds of inspiration with a word of thanks.

SUPPLIES: Journal or poster board, loose-leaf paper, pencil or pen

You may also need: Glue stick, scissors, favorite art supplies for color and collage, favorite stationery

PART 1: W.O.W.

STEP ONE: In your journal or on a piece of paper, make a list of people you admire, both real-life mentors and heroes. The list can be as short or as long as you like.

STEP TWO: Gather images of those people who inspire you. For those you don't know in real life, look through magazines or search online. Set the images aside.

STEP THREE: Using the images as reference, draw or doodle portraits of your mentors and heroes in your journal or on a poster board. Alternately, you may paste the photos, magazine clippings and computer printouts onto the pages. Leave space between each one.

STEP FOUR: Write a memory, inspiring quote or admirable trait you associate with that person below or beside each image.

STEP FIVE: Keep the Words of Wisdom (W.O.W.) album close by. When you meet or find a new hero, add him/her to the list.

PART 2: THANKS

Write a letter to someone who has made an impact on your life (maybe it is someone in your W.O.W. album). It can be a short note just to say "thanks" or a letter detailing how that person has made a difference. Feel free to write the letter on pretty stationery and send it in the mail, but know that an e-mail is fine, too. If you don't know the person's address, publish it as an open letter on your blog, tuck it away in your journal or toss it in the trash. The simple act of writing a letter can be therapeutic and invigorating.

56

PHOTO BY CHRISTINE CASTRO HUGHES

TURNING TO THE LIGHT
CREATED BY MCCABE RUSSELL

"WHEN I START TO FEEL OVERWHELMED, DOWN, OR JUST PLAIN BLOCKED, I TURN TO TEACHERS AND KINDRED SPIRITS TO GET MYSELF BACK ON TRACK." –MCCABE RUSSELL

I must admit that when I was asked to create an exercise for this chapter, my mind completely blanked. An exercise? About beacons of light? Is there anything I could suggest that would remotely pass as useful? I tend to hibernate when I feel blocked and eat cherry Twizzlers under the covers.

It goes something like this: I'm in a creative slump. It starts off small and then snowballs. The more I focus on what I am not doing, the worse it gets. Depression sets in, with guilt and shame right on its tails. The same thought runs in continuous loops in my mind: If I could just do *X* and follow through on *Y*, everything would be OK and I would not feel so dried up.

But then I started thinking and remembered that I do manage to pull myself out of the I'm-not-doing-anything-creative cave or else I would not be here. So what do I do? It is simple: I remember my beacons—the ones who inspire me, encourage me and show me the way, those who have gone before me and provided the inspiration I needed to take my own creative dreams for a walk around the world.

The challenge? Transforming this energy into something positive—taking the negative and creating something fun.

The solution: *Remember My Beacons*.

HERE'S HOW IT WORKS:

1. Spend ten minutes making a list of everyone who has inspired, guided or supported you in the last year. It can be someone you know, someone you'll never meet, a family member, a friend.

2. Review your list. How many of those individuals have you connected with—either in person or from afar, such as through reading their books—in the past month? Week? Day?

3. Select four of these individuals. We'll call them your Beacons.

4. Every week for the next four weeks, make a point of connecting with one of your Beacons—if it is a friend, schedule a phone call or coffee date. If it is one of your favorite authors, set aside an hour to read one of his or her books. If it is a family member who has passed on, write him or her a letter asking for the guidance you need; tuck it under your pillow, record your dreams the next day.

Connecting with my beacons not only feeds my creative spirit, it gets me out of my head and house, away from negative voices that are weighing me down. I turn toward their light, let it wash over me and then suddenly, I'm back to my old self.

ARTWORK BY PENELOPE DULLAGHAN

chapter five

twists, turns and other beautiful surprises

It's All About the Journey

66 There is always plenty of room for goal setting, priority listing and action plans, but sometimes the simple act of holding an intention quietly is enough to feed the dream and give it room to grow. 99
Christine Mason Miller

"THE MOST UNEXPECTED INSPIRATIONS I EXPERIENCE COME WHEN I CLIMB A MOUNTAIN HIGHER THAN I THINK I CAN. WHEN I PROVE TO MYSELF—AS WE ARE ALL CAPABLE OF—THAT I CAN MANIFEST WHAT I SET OUT TO DO." –PIXIE CAMPBELL

In this quote, Pixie speaks to the surprises that await us when we are willing to dive deeper, reach farther and leap more magnificently than we think we're capable of. As a rookie business owner mapping out my journey as I went along, there was no way I could have predicted being able to pay off my first business loan within thirty days of receiving it. The story I shared in chapter three about the partnership with my dream was not only about that alliance, but also about the wide array of impossible-to-anticipate gifts that are in store for me when I take a leap. After two decades of pursuing dreams as varied as earning a master's degree to visiting Jordan, I can safely say all of my most meaningful, fulfilling experiences begin the same way: "I would have never imagined it in a million years."

A few of my favorite twists, turns and other surprises:

- *Visiting Cuba in March 2006.*
- *Launching my self-published book* Ordinary Sparkling Moments *at a beautiful, creative gathering with most of my best friends.*
- *Learning how to step into my role as a member of my husband's family, a circle I now simply call my family.*
- *Becoming a published writer.*

While I wish I had the time (and page space) to share the details of each of these stories, the more important point is that these experiences—and countless others—have enabled me to develop a profoundly deep trust in the process of my life and dreams. When I set an intention, do my best work and reserve judgment on everything, I become more deeply attuned to the natural flow of my life. This practice of surrender instead of resistance opens my awareness to all the gifts that are available to me everywhere, in every moment.

PHOTO BY CHRISTINE MASON MILLER

> **66** Inspiration comes in a moment of no control. **99**
> Andrea Kreuzhage

"...THEN THERE WAS THIS TREK—WE WERE CLIMBING UP A MOUNTAIN TRAIL AND SUDDENLY THERE WAS A TURN IN THE PATHWAY. WE KEPT WALKING, TURNED ALONG THE CURVE AND WERE SUDDENLY CONFRONTED WITH A VALLEY FULL OF FLOWERS—OUT OF THE BLUE, WITH NO WARNING, AN ABUNDANCE OF COLOR AND SOFTNESS. LIFE CAN BE LIKE THAT—YOU ARE TRUDGING ALONG AND THEN, SUDDENLY, YOU ARE IN BOUNTY."
–VINEETA NAIR

The unpredictable nature of following dreams and creating a meaningful life is perhaps the only certainty that exists along these journeys. There are no guarantees in even the best laid-out plans; one way or another the details of life are going to trickle in and force me to re-evaluate, venture into unknown territory, or abandon certain items in my metaphorical backpack. No matter how carefully I consider every possibility, no matter how much effort I put toward training and preparing, I will always, without fail, experience long stretches of time when I feel like I'm wandering without a map. Thanks to a long history of experiences akin to Vineeta's sudden "abundance of color and softness,"

I have developed a deep appreciation for those seemingly aimless treks. Just because I feel lost, it doesn't mean I'm not still headed in the right direction. On those parts of my path, my work is simple: Put one foot in front of the other.

Marianne Elliott describes a night spent alone in Dubai, a stop on her way back to her native New Zealand after living and working in Afghanistan for two years: "I felt utterly adrift," she explains, "I had no sense of where my home was anymore, no sense of solid ground beneath my feet. So I leaned into trust: I took the next step on the path I found in front of me and as I continued to do so—one day after another—I found that I had everything I needed."

Andrea Kreuzhage explains, "To feel inspired means taking one step and then another—getting closer to and more deeply involved with all the possibilities of an authentic life." Even with a clear vision of where I want to go, or who I want to be, I've never been handed an instruction manual for these endeavors—they have all been exercises in taking one step at a time, trusting my intuition and keeping my heart and mind open even when the weather turns ominous.

66 At the tender, transformative age of twelve, I was devastated by our family's move from Montreal to Toronto. I thought I'd never feel at home or find my way. For about a year I was sullen, moody and depressed. Then one day the light came on; if I wanted a teenage life full of friends, fun and adventure, full of water fights and movie nights, I'd have to create it—and so I did! And I've been making things happen ever since. There's no need to wait for life to come to you. Bring what you have to life and let the adventure begin! 99
Jamie Ridler

PHOTO OF 11-YEAR-OLD JAMIE RIDLER

SPEAKING OUR TRUTH

BY KATE SWOBODA

A few months into working for myself, I was
logging crazy 60-hour weeks, worrying over
every detail. I had been working one-on-one with
coaching clients on a part-time, as-they-come
basis for four years, but once I shifted into
full-time self-employment, I was thrown into
completely new territory—juggling clients, running
an e-course and planning a retreat, alongside an
endless stream of marketing tasks, blog updates
and computer issues. I felt confident in the realm
of working with people, but awkward when it
came to gracefully spreading the word about that
work. And I was afraid to discuss it, because my
inner critic was strong, telling me that since I was
finally "following my dream" I was supposed to be
happy—all of the time, every second.

Around this time, I went on road trip to the
coast of California and took a series of pictures
and videos. Back home, I felt inspired to pull it
all together and in the video I assembled, I got
honest about what I'd been feeling. And then I
did something that felt kind of scary: I posted the
video online.

Soon after, tweets, e-mails and so much
love poured in. This thing I'd been so afraid
of admitting—that I was scared, that it
wasn't all roses—ended up being a fount of
connection. Again and again, people expressed
their gratitude that someone spoke about
something they were also experiencing—feeling
disconnected from themselves, worrying they
weren't enough despite their best efforts. I was
honest about who I was and that was celebrated—
confirmation that the greatest gift we can give to
one another as human beings is simple: our truth.

PHOTO BY VINEETA NAIR

62

❝Explore rather than expect.❞
Mary Anne Radmacher

"IN MY FIRST YEAR OF GRADUATE SCHOOL, I HAD A PARTICULARLY DIFFICULT CONFRONTATION THAT CAME OUT OF NOWHERE. MY CHARACTER WAS DIRECTLY CHALLENGED AND DURING THIS EXPERIENCE, I FELT TRULY PROTECTIVE OF MYSELF FOR THE FIRST TIME. FOR AN ENTIRE HOUR, I SILENTLY WHISPERED TO MYSELF, 'YOU ARE STRONG AND CONFIDENT.' AT THE END OF THAT EXPERIENCE, I COMPLETELY TRANSFORMED. I FINALLY HEARD MY VOICE AND WASN'T WILLING TO MUFFLE IT AS I HAD UNTIL THEN. I STARTED MY BLOG, A BEAUTIFUL RIPPLE EFFECT, THE NEXT DAY. THE EXPERIENCE SERVED AS MY WAKE-UP CALL AND I AM SO GRATEFUL I LISTENED."
—CAROLYN RUBENSTEIN

It is easy to recognize gifts when they land on my doorstep adorned with balloons and glitter, sometimes less so when they appear "in disguise." In those situations, when I am tempted to immediately attach a label to whatever is in front of me, I think about what Anne Carmack says about living a life of passionate mindfulness: "Where did we get the idea that life was supposed to be anything other than a disobedient, disorderly, riotous ride? Who promised us the calm without the chaos, the muse without the mess, the love without the longing?" The real challenge in embracing all the twists, turns and other surprises in my life is to resist the urge to see them as absolutes—to sit still and let the story unfold before I >>

insist on deciding something "bad," "a failure," or "not what I wanted." A rejection here can mean a better opportunity there; a failed endeavor in one place makes room for something new in another space. A challenge or disappointment can be an opportunity to put a new practice in place—to live by my values as opposed to merely talking about them. Each experience, whatever my interpretation, has its place in the story of my life. As Christen Olivarez explains, "We spend so much time trying to move past our failures, rather than accepting that they are part of us, but these vulnerable moments are full of light and inspiration. The more we open ourselves up to that—to the good and the not-so-good—the more channels we have to connect with others." The real magic of life's curveballs is that they are all part of a process, a process I might not be able to make sense of in the moment, but can appreciate and trust nonetheless.

ARTWORK BY ANNE CARMACK

64

Make It Real

"THE MAJORITY OF MY INSPIRATION IS SPARKED BY NORMAL, EVERY DAY LIFE AND THAT IS STILL KIND OF SURPRISING TO ME. I WOULDN'T HAVE IMAGINED IT YEARS AGO—THAT I WOULD BUILD AN ENTIRE LIFE PHILOSOPHY AROUND 'THE EVERY DAY'. IT IS WHAT MAKES ME THE HAPPIEST NOW, CAPTURING ALL THE TINY MIRACLES OF LIFE THAT CAN BE EXCAVATED FROM THE MOST MUNDANE MOMENTS." –TRACEY CLARK

Every twist, every turn and every unexpected fork in the road is an opportunity to *receive*. As your partnership with your life, your dreams and your values deepens, the practice of recognizing the entirety of your journey—of standing back and considering the "big picture"—becomes second nature. Through this, day-to-day habits shift away from premature assumptions and immediate judgments toward calm acceptance and a profound trust in the process of how your life is unfolding.

> **66** May we sit with our tools
> and honor each messy,
> sacred moment with them. **99**
> Pixie Campbell

PHOTO BY PIXIE CAMPBELL

YOUR OWN PERSONAL FIELD TRIP
CREATED BY LIZ KALLOCH

"PUT ON YOUR BRAVE, AND STEP INTO THE MOMENT."
–LIZ KALLOCH

Over the past decade, our world has gotten both smaller and larger thanks to the Internet. In the creative community in particular, we can see our peers at work and tune into their successes. While inspiring, it can also lead to moments of distraction, when too much time reading about what other people are doing begins to take away from doing our own work. A field trip can provide a beautiful channel of inspiration, giving you an avenue to shed the overwhelm and remember who you are. I take myself on field trips a few times a month and they always give me a new perspective on my painting and design work.

SUPPLIES: Journal, pen, camera and open, receptive eyes

STEP 1: TAKE YOURSELF OUT.
Step out of your studio or office and away from your computer—far from other people's thoughts and dreams—and into a place of remembering your own dreams. This is your time to be, think and feel what is going on inside of you. Put away thoughts of what others are doing and focus on your dreams and goals. Starting your journey from within is truly the best place on the map of your life.

STEP 2: TAKE YOURSELF SOMEWHERE PUBLIC.
Head somewhere in your neighborhood or town, somewhere where there are people, sounds, colors and activity. Here are some of the places I have visited in the last six months:

- Thrift store
- Public park
- Gallery
- Playground
- Library
- Hardware store
- Stationery store

ARTWORK AND PHOTOS BY LIZ KALLOCH

STEP 3: WANDER.

Look around you—really explore the details. What shapes do you see? What colors make you feel happy? Are there intriguing shadows? How are people around you interacting with each other? What are you feeling drawn to? Does anything make you feel uncomfortable or upset?

STEP 4: STOP AND FEEL WHERE YOU ARE IN THIS MOMENT, RIGHT NOW.

What feelings are coming up? What are you thinking about? Write anything and everything and pay attention to what surprises you. Draw quick sketches of things you see; document what sticks out to you, something you feel is important to remember. All of these things are important and worth remembering.

STEP 5: TAKE SOME PHOTOS.

Point your camera at whatever catches your eye, without thinking too much. Leave aside the need to create the perfect photo; think of these photos as a document of your field trip. These photos will provide tangible memories of your thoughts and experiences.

STEP 6: RETURN TO YOUR STUDIO, OFFICE OR CREATIVE SPACE.

Look around. Review the projects you are working on, look at your wish lists and to-do lists. Then look at what you wrote during your field trip and peruse your photographs. I often print some of the photos I took and put them on my bulletin board. I am fairly certain that something you notice, experience or feel will add a new spark to what you are currently creating.

67

PHOTO BY CHRISTINE MASON MILLER

66 Just this morning, I took a walk around the neighborhood where I grew up and found the most gorgeous colors in the grass and gardens. How many times have I passed them by without even a glance? But today, because I was walking a little more slowly, I saw them like they were shiny and brand-new. It caught me off guard in the best possible way. I remembered that inspiration is everywhere, all the time, waiting for us to find it. Sometimes, we just have to take a moment to notice. 99

Christine Castro Hughes

FINDING YOUR OWN PARADES
CREATED BY MARY ANNE RADMACHER

**"HAVE THE COURAGE TO WALK OUT YOUR DOOR AND PARADES WILL FIND YOU."
–MARY ANNE RADMACHER**

People express assumptions about the inspired artistic life. I hear, "You are so lucky. You get to just sit around all day and create."

Laughingly I'll reply, "Don't forget about eating bonbons."

One thing is certain—I *am* lucky. My life intention is also how I earn my livelihood. Of course there are tasks in the day that have less appeal than others. Allowing for twists, turns and other beautiful surprises can turn those undesirable activities into adventures. Small, seemingly ordinary activities can provide basic training for extraordinary journeys that await an open and inspired heart.

Case in point: Each day was so packed full o' fun I'd postponed a trip to the post office for five days. A pile of donations, gifts, promotional materials and treats for my adopted soldiers had grown quite large, but I was dreading having to haul so many boxes. It felt like an interruption.

Time for a twist! A "Yes" instead of five days of "No."

I kicked dread out the door and I invited my attitude to shift into adventure. I cranked up my tunes and started loading all those boxes. I believe that if I'm just willing to walk out the door, parades might find me! So I brought my camera along, just in case.

> **"** I can't get so caught up in future plans and my self-prescribed ideals that I lose sight of right now. Because now is what matters most. **"**
> Christen Olivarez

As I gathered the first stack of packages for the post office I heard, "Would you like some help with that?" Reminding myself that this was supposed to be an adventure and that I didn't have to do this all myself, I said, "I would! Would you take my picture with some of these boxes?" The gentleman didn't even ask why, he just happily took a photograph. Afterwards, he offered help with the boxes again. And again I said, "Yes!"

On our next trip back to the car for more boxes his friend Jim ambled up and said, "Am I in time for the parade?" Another enthusiastic "Yes!" until the conversations and transport of boxes had the entire postal staff laughing more than they had all day. We had three more offers of help and I met two members of my community who had previously been strangers.

The beautiful surprises of the artful and inspired life come when we are willing to twist our way out of negative views and be open to other—positive—possibilities. They invite themselves in when we agree to turn from dread, unhappy procrastination and resistance toward synchronicity and the wonder of surprise.

What are you resisting, neglecting or putting off?

Take one element of what you are resisting and invite yourself to turn it into an adventure. Be open to at least feeling good about finishing it and perhaps an even greater surprise will tap you on the shoulder. At the very least you'll surprise yourself with relief at the accomplishment, the assessment of "that wasn't so bad," or just maybe you'll be startled by the parade that discovers you. At the end of the "adventure" make some notes about the experience in your journal and ask yourself to record what you learned in the process.

69

PHOTO OF MARY ANNE RADMACHER BY THE GENTLEMAN AT THE POST OFFICE

PHOTO BY TRACEY CLARK

chapter six
the ripple effect of inspiration

Small Acts Can Have a Big Impact

66 The kindness you read about in books or see on television matters, but the most important kindness is often overlooked—the ordinary sparkling kindness we nurture for ourselves and share with others. 99

Carolyn Rubenstein

PHOTO BY
ANNE CARMACK

72

"WHEN WE FOCUS OUR ENERGY TOWARD CONSTRUCTING A PASSIONATE, MEANINGFUL LIFE, WE ARE TOSSING A PEBBLE INTO THE WORLD, CREATING A BEAUTIFUL RIPPLE OF INSPIRATION. WHEN ONE PERSON FOLLOWS A DREAM, TRIES SOMETHING NEW, OR TAKES A DARING LEAP, EVERYONE NEARBY FEELS THAT ENERGY AND BEFORE TOO LONG THEY ARE MAKING THEIR OWN DARING LEAPS AND INSPIRING YET ANOTHER CIRCLE." –CHRISTINE MASON MILLER, FROM *ORDINARY SPARKLING MOMENTS*

Imagine a landscape filled with trash and debris; a bleak expanse of lifeless gray. As you scan the horizon, you suddenly notice a burst of color. Amidst a sea of rubbish, there is a thriving garden—flowers and plants, growth and beauty. Over time, you see that garden blossom, aware that the seeds it has created are being quietly scattered in every direction. Before long more flowers take root, new gardens burst forth, and your world has slowly transformed. In a culture that has no shortage of bad news and dire predictions, this is the chain of events you create when you pursue your calling on any level. Every step taken toward your most passionate, meaningful life is the highest service you can offer the world—*every single step*.

A quick glance at some of my most recent inspired moments offers these examples:

- *Hearing a close friend talk about his daily practice of spiritual study.*
- *Perusing a fellow blogger's travel photos.*
- *Watching my niece and nephews create their own art books on my dining room table.*
- *Listening to a friend explain that she turned down a job offer because she knew it wasn't right, even though she had no other leads.*

These moments did not involve extraordinary feats of daring or risk on the part of any of those I was observing; they came about because each person was sharing his or her own unique ideas, adventures, experiences and creative flairs. Because I happened to be a fortunate witness, I was rewarded with light and inspiration. My friends and family likely weren't aware they were inspiring me. They were just being themselves, and in doing so, shined a lantern on my path.

66 It's less about pushing toward the edge of some gigantic courageous risk and more about nudging gently toward the truth. Even the smallest steps count. 99

Anne Carmack

"THE NUMBER ONE CHALLENGE I HEAR FROM CLIENTS, FRIENDS AND COLLEAGUES IS THAT THEY DON'T HAVE ENOUGH TIME FOR CREATIVITY. THE BELIEF THAT THEY NEED HOURS, DAYS OR EVEN WEEKS TO EXPRESS THEIR CREATIVE SPIRIT HOLDS THEM HOSTAGE, PREVENTING THEM FROM TAKING ANY ACTION AT ALL. THIS LEAVES THEM DEPLETED, DISCOURAGED AND ACHING FOR THE JOY THEY KNOW CREATIVITY HAS TO OFFER. IT DOESN'T HAVE TO BE THAT WAY. OUR LIVES ARE MADE UP OF MOMENTS—BY FILLING THEM WITH OUR CREATIVE SPIRIT, WE BRING OURSELVES AND THE WORLD ALIVE." –JAMIE RIDLER

As I write this chapter, Jamie Ridler is hard at work putting the finishing touches on her latest e-course. Called "Sparkles," it is a 31-day course that delivers a simple prompt designed to bring the participants' creativity to life in five minutes or less each day. Jamie elaborates: "Instead of time being a limit—something that keeps us from our creative expression—I want to demonstrate time as the precious gift it is. In only five minutes it is possible to shift our mood, play, discover, explore, create, think, expand, laugh, dream, wonder, love and connect! Creativity can become an integral part of who we are and what we bring to the world and it can happen in the smallest of ways."

Jamie's understanding of the impact of small details began in the world of theater. "On stage, you experience how a simple shift in lighting or change in costume can transform everything. Every detail is rich with meaning and expression and I knew this was also true in life. A tulip on the table makes a difference. A flaming red scarf makes a statement. Every choice matters." Motivated by all the ways her own small acts of creativity have kept her on the path toward her most meaningful life, Jamie's mission is to encourage others to take advantage of the countless opportunities available each day to express their own creativity.

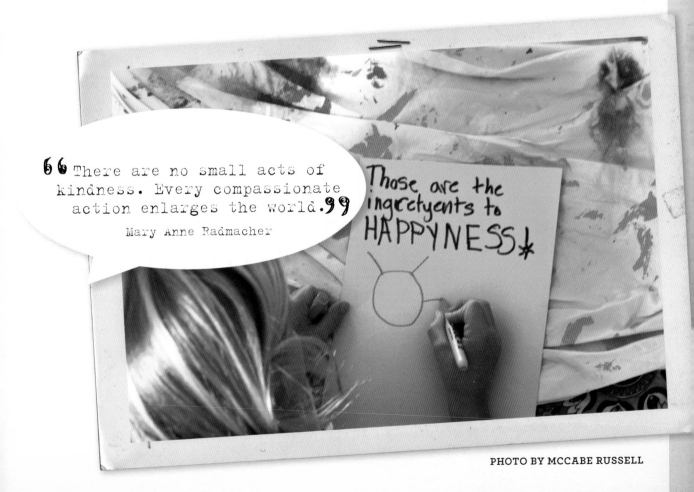

66 There are no small acts of kindness. Every compassionate action enlarges the world. 99
Mary Anne Radmacher

> **" I am inspired when someone has the courage to walk their path; and when I share my path and process, maybe someone else will think, 'If she can do it, so can I.' It's a thought; it's a beginning."**
>
> Vineeta Nair

"ILLUSTRATION FRIDAY IS A WEEKLY CREATIVE OUTLET AND PARTICIPATORY ART EXHIBIT FOR ARTISTS OF ALL SKILL LEVELS. WE BELIEVE THAT EVERY PERSON HAS A LITTLE CREATIVE BONE IN THEIR BODY. ILLUSTRATION FRIDAY JUST GIVES A NO-PRESSURE, FUN EXCUSE TO USE IT ... A CHANCE TO EXPERIMENT, EXPLORE AND PLAY." —ILLUSTRATION FRIDAY WEBSITE

With the click of a mouse, it is monumentally easy for me to keep track of what my fellow artists, entrepreneurs and dreamers are up to. While I wish I had the time and energy to maintain closer connections with those who live farther away, I am grateful for the opportunities blogs and websites provide to keep the channels of inspiration between myself and women around the world wide open. Penelope Dullaghan, who lives more than two thousand miles away, has been a steady source of inspiration for me ever since I met her at a retreat I organized in 2006, just over two years after she launched Illustration Friday (IF), a website that has opened one of the most meaningful and inspiring channels of inspiration available online.

"I started Illustration Friday because I was feeling pretty isolated in my home studio and wanted to connect with other creative people," explains Penelope. "I'd also heard that when you start out as a freelance illustrator it's wise to only show work that you want to do more of. So I started IF to pad my portfolio with fun work." Each week a new topic is posted and e-mail alerts are sent out. Participants post their submissions on the IF website, which enables viewers to browse submissions by medium and style, read artist interviews, participate in ongoing art forums, and enjoy the contributions of ten different IF bloggers. What started as a simple weekly invitation to create blossomed into a bona fide movement, with nearly one thousand participants each week from all over the world. "With IF, my goal is to inspire people to create for the sake of creating," says Penelope. "I feel fortunate to be able to offer the site as inspiration, and even more so because participants inspire me as well."

Receiving a new creative pebble each week, with ripples spreading far and wide, participants are inspired to toss in their own pebbles, which create new waves that crisscross, overlap and make their way right back to Penelope. Literally tens of thousands of new creations have been executed and shared through IF, a virtual library of artistic adventures.

35 GOOD THINGS

BY CHRISTINE CASTRO HUGHES

I've been trying to think of something good to celebrate my upcoming birthday. After all, I'm turning 35. That's a big one. I thought about throwing a fancy shindig or taking a luxurious vacation. I considered cutting off all my hair or buying something extravagant. But none of that sounded quite right, so I thought about what being 35 means to me. Now that I've lived through half of my 30s, I can say with certainty that I am wiser. I am more sure of myself. I know I am a good person, but I know I could be better. I also know that being good doesn't have to be hard. Sometimes, a smile to a stranger can turn the whole day around (for both the stranger and myself). It's those simple gestures that inspire me and have inspired my birthday plan.

I am going to try to do 35 good things in the next 35 days. These might be tiny tasks or involve a grand plan. They may take thirty seconds or span a whole weekend. They may involve a stranger, a friend, a family member, or myself (because I deserve a little kindness, too!). One thing's for sure, though: They are gonna be good.

Excerpt from brunchwithdarling.com, October 18, 2010.

"we don't spend enough time looking up," he said.

"i know," i said
& pointed my head upward.

just then, i saw a balloon
floating toward the sun.

it was a sign.

ARTWORK BY CHRISTINE CASTRO HUGHES

"MAKE. THE. MOST. OF. YOUR. TIME. HERE." —AMY KROUSE ROSENTHAL

In the summer of 2008 author Amy Krouse Rosenthal was inspired to create a short video entitled "17 Things I Made," which documented a list that included her children, a bed, a sandwich and a mess in her kitchen. The spark came to her in the middle of a concert and the video launched a project called *The Beckoning of Lovely*. Described as "an expanding film project involving hundreds of strangers from around the world," Amy's film and the events supporting it were created to celebrate "the power of community, connection and hope amongst strangers in the name of all things lovely." She has created eight videos, hosted gatherings in eleven U.S. cities and received more than four hundred submissions—of artwork, photography, poetry, music and writing—for an opportunity to be featured in *The Beckoning of Lovely* feature film. One small garden spread seeds to a photographer from Guam, a poet from Israel, a writer from Lithuania and artists from all over the U.S. All of this creative goodness from one three-minute video assembled to celebrate one thing: the joy of the ordinary.

❝ When you shine, you
light the way. **❞**
Jamie Ridler

"THE RIPPLE EFFECT OF INSPIRATION IS LIKE A GRID OF GOOD WRAPPING AROUND OUR PLANET—A NETWORK OF SHARING, GIVING AND TAKING—ALWAYS GROWING AND EVER EXPANDING." —ANDREA KREUZHAGE

These three examples demonstrate that when small steps are taken with the express intention of creating ripples of inspiration, anything is possible. The same truth applies when steps are taken on a smaller scale, such as when an idea or dream is pursued simply for the sake of one's own enjoyment, curiosity or personal inspiration. The very act of taking a step is going to have an impact; I am inspired by the actions of others on a daily basis and most of the time the only thing they are doing is going about their business. Looking at the community of contributors to this book, I have no problem thinking of moments when each of them has inspired me in small yet meaningful ways: The way Christine Castro Hughes writes thank you notes; the attention Pixie Campbell gives to every package she sends me (with beads, feathers and colorful yarn); the colorful skirt-over-jeans ensemble worn by McCabe Russell the first time I met her. All the ways these women express themselves in their day-to-day lives—all the ways they give time and attention to everything they put forth in the world—each of these actions matter and contribute to the larger currents of inspiration traveling through the world every day.

IMAGES FROM THE FILM *THE BECKONING OF LOVELY* **BY AMY KROUSE ROSENTHAL**

ANNE CARMACK AND THE GREAT ARTISTS PROJECT

The Letter Says It All

Dear Anne,

I am writing to explain a preschool project we are doing because you are a major part of it—sounds interesting, doesn't it? Each year at preschool all the classes work on a Great Artists project. We each choose a different artist and study their techniques. Then the children create their own art in the style of the chosen artist. In the past, our class has done art in the style of Picasso, Monet, Seurat, Nevelson, Morisot, Dorothea Lange and several others. This year we would like to do our art in the style of Anne Carmack.

Last year my teaching partner and I saw your exhibit at the library, really liked it, and thought you would be a good choice. We also like the fact that you have roots in University City. When the students are finished working on their art, we have a gallery display in a large room at school so parents can see the work. I took pictures of your pieces and can identify, I think, some of the techniques you use, but would love to hear from you about how you create your art and how you started this work—anything you have to share with us would be great. The pieces in which you use photos or pictures are the ones that we may focus on.

I hope that all is well and wonderful with you.

Thanks, Fran

January 2011

PHOTOS BY ANNE CARMACK

> **Life is a beautiful and virtuous circle of giving and receiving.**
> Mindy Tsonas

66 Whether we cross certain accomplishments off our life lists or sit in lotus for the next forty years, it all matters. Without planning it, naming it, thinking it, designing it, coloring it, teaching it—it all matters without anyone ever even knowing about it. 99

Pixie Campbell

Make It Real

"BOLD GENEROSITY IS THE BEST RESPONSE TO WIDESPREAD ALLEGATIONS OF SCARCITY. INSPIRATION SPREADS MORE ACTS OF COURAGEOUS GENEROSITY." —MARIANNE ELLIOTT

It bears repeating: Every step taken toward your most passionate, meaningful life is the highest service you can offer the world. When you honor the sparkle within you—as a mother, a gardener, a runner—you light the way for others to do the same for themselves. You can set an example for possibility and passion by doing something as simple as taking an art class, writing an authentic blog, or preparing a beautiful dinner party. The world needs your spark—your beautifully unique and powerful spirit—and every step, no matter how small, matters.

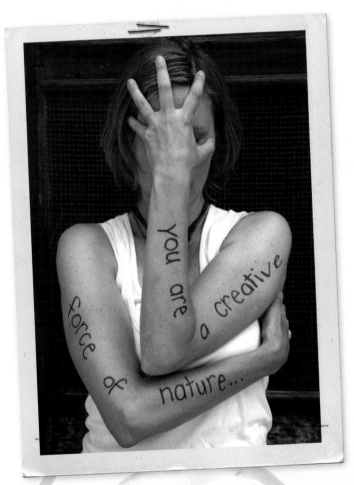

**PHOTO OF CHRISTINE MASON MILLER
BY JEN GRAY BLACKBURN**

STEPS, BIG IMPACT
CREATED BY CHRISTEN OLIVAREZ

"THE KEY TO STAYING FOCUSED ON THIS PATH LIES IN MY DAILY JOURNAL WRITING. IT'S ON THOSE PAGES THAT I REMIND MYSELF OF WHAT I WANT TO GIVE, WHAT I HAVE TO OFFER AND WHAT I'M MOST GRATEFUL FOR."
–CHRISTEN OLIVAREZ

I have an art journal on my desk that I work on every day, using whatever supplies are available—usually paint, masking tape, pens and maybe a stamp. Some days I'm only able to paint a background; others allow time to record my feelings. At the end of each week, every tiny step I've taken results in a journal page that is dripping with emotion and authenticity.

My office colleagues became fascinated by this process and have since started daily work on their own journals. Little by little, we are each making a difference in our own lives. My daily journal habit was not only merely noticed by those around me, but had a big enough impact to inspire them into action.

The following exercise is an adaptation of something I do every day. It shows that spending as little as five minutes a day feeding your creative soul will add up to something more meaningful than expected. Each step will be done on a different day and should take no more than five minutes.

DAY ONE: SUPPLIES
Give yourself five minutes to gather your supplies for the week. You will need an art journal or small canvas, scraps of paper, two to three colors of acrylic paint, gel medium and a paintbrush. I like to do this at my desk at work, where I also have extra pens, tissues and glue.

DAY TWO: THE FOUNDATION
To create a background, squeeze a few drops of different paint colors onto your canvas and use your fingers to spread them out. Be careful not to mix them too much or they will become muddy. Don't be afraid to leave some areas of your canvas white.

ARTWORK AND PHOTOS BY CHRISTEN OLIVAREZ

DAY THREE: TEXTURE

Apply paint to a pen cap or marker cap and stamp it repeatedly on your background for some texture. Use a tissue to lift up some of the paint and stamp with other objects—use fingerprints to create a scallop edge and the side of a pencil for stamped lines.

DAY FOUR: LAYERS

Tear up scraps of paper—receipts, notes, fortunes and wallpaper. Anything will work great! Apply gel medium to the front and back of the scraps and adhere them to your page.

DAY FIVE: MORE LAYERS!

Add more paint texture—dab it with a paper towel, wipe some off, smear it. Be willing to experiment.

DAY SIX: JOY

On the canvas, write a list of small things that bring you great joy.

DAY SEVEN: THE FINAL TOUCHES

Take a good look at your canvas. Is there anything else you'd like to add, cover up or try? Add the final touches, date your journal page and you're finished!

PHOTO BY CHRISTEN OLIVAREZ

> 66 We don't know where and when the ripples of inspiration come ashore. But they do travel! 99
> Andrea Kreuzhage

ONE ACTION AT A TIME
CREATED BY CAROLYN RUBENSTEIN

"IF WE DECIDE TO BELIEVE IN OURSELVES, THEN NOTHING CAN DIMINISH OUR POTENTIAL." –CAROLYN RUBENSTEIN

Have you ever thought, "Why try? I am just one person. What difference can I make?" I imagine many of us have had this thought now and then—even those we look to as heroes and champions. This thought—this inkling of doubt—when recognized, is a magical gift. Are you ready to begin unraveling this gift?

STEP ONE: RECOGNIZE THOUGHTS THAT QUESTION YOUR POTENTIAL.
Some examples:

"I only have a few dollars to donate, what difference will that make?"

"Why would Alex want to hear from me? I'm sure she has other friends to console her right now."

"I'm not an expert. Why would anyone care what I have to say?"

STEP TWO: WRITE DOWN THOSE THOUGHTS—MAKE THEM TANGIBLE.
Thoughts like these typically produce the same result: inaction. We back away and choose to avoid the possibility that maybe we're wrong, that maybe we *can* help. Consider instead that perhaps the world is waiting for us (for you!) to do something, even if it seems insignificant from your perspective.

STEP THREE: CHALLENGE THE THOUGHTS THROUGH ACTION.
After writing down your negative thought, challenge it with an action you can take to prove it wrong (the smaller and easier, the better).

Let's refer to this action as an itty-bitty action. (Much less scary, right?) Some examples:

"I can (and will) donate two dollars to this cause."

"I am going to write Alex a thoughtful note and let her know I am here to support her."

"Someone like me would care—she would want to hear from a 'non-expert.' I'm going to share my thoughts and trust my colleague will be gracious and listen without judgment."

STEP FOUR: KEEP A SACRED CHANGE DIARY
Each time you take an action that challenges a limiting thought, record your experience in your Sacred Change Diary. How did it make you feel? How did your friend respond? How did your efforts, insights or contributions make an impact you hadn't expected?

Some examples:

"I donated two dollars to the cause and it made me feel like I was part of a larger community making a difference."

"I mailed a letter to Alex with a bag of my favorite tea. She called the next day and said it was exactly what she needed."

"I spoke with my co-worker about my thoughts on this situation and he has decided to change the focus of our project. This inspired another division to shift their work in the same direction—I had no idea that would happen!"

This journal serves as a reminder that the actions you take will reinforce your potential—threatening (and powerful) evidence for the gremlins that creep up and challenge your ability to make a difference.

After you've experienced the power and impact small actions can make, share this magical gift with others. By sharing this exercise, you will empower others to begin their own inspiring acts and see how far one person's actions can reach along the beautiful ripple that is created. Imagine if you complete 21 small actions in as many days and then share this exercise with 21 other individuals who follow your example. That's 462 actions and one tremendously inspiring ripple effect!

Wholehearted passion changes the world one person, one action, at a time.

may respect be the first course at each meal.

may the table ever be big enough and, at the ring of the bell,

may there always be discovered a friend at the door.

ARTWORK BY MARY ANNE RADMACHER

84

chapter seven

plenty of room for everyone

Understanding Our Unique Place and Purpose

> ❝ We can never be 'not enough,' because we are part of this greater whole. There is no need for us to be bigger or better, or more of anything. We are already exactly the right amount of that greater whole. Each of us is already perfectly equipped to love and serve the part of the world that is within our reach. ❞
>
> Marianne Elliott

"EVERYONE HAS SOMETHING TO OFFER. EVERYONE. OWN YOUR STRENGTHS AND TALENTS. ASK YOURSELF THE HARD, UNCOMFORTABLE QUESTIONS. WHEN YOU FIND YOURSELF IN A SITUATION WHERE YOU ARE CONTENT AND PRESENT—PAY ATTENTION. THIS IS WHERE YOU BELONG." –MCCABE RUSSELL

Fresh out of graduate school and eager to embark upon my dream of being a professional artist, one of the first things I did after starting my business was apply for a space in the Santa Barbara Yes Store. This holiday co-op is open for six weeks each year—always in a different location—and gives more than twenty local artists an opportunity to sell their handmade goods. It is a juried event, and in addition to presenting samples and photographs of my work, I had to include detailed plans for my display. I found out about this opportunity just before the deadline, so while I did not have much time to prepare, I submitted my application confident I had a chance.

66 Inspiration = Liberation. Free yourself of needing results. Free yourself of fearing failure. Your unique, inspired space has room for false starts, experiments, adventures. 99
Andrea Kreuzhage

> **"**Let go of your expectations about life. It will never be what we imagine it to be. Trip, fall, get lost, break down, then pick yourself up off the ground, laugh and carry on.**"**
>
> Christen Olivarez

My work was not accepted and although disappointed, I was still eager to see the store once it was up and running. The day after it opened, I took a long tour of the store before leaving abruptly in a puddle of tears. I was devastated, feeling like there were too many artists who were already way ahead of me—more professional, experienced and talented than I could ever hope to be—and that it would be impossible for me to reach their level. Not only did I feel overwhelmed by all the details I had yet to learn, I also berated myself for even thinking there was a place for me amongst such an extraordinary circle of artists.

The following year, after twelve months of trials, errors, and a string of small successes, I re-applied and was accepted. I continued to be welcomed back into the store every year I applied, developing a hectic holiday routine of trying to keep up with sales that emptied my shelves on a weekly basis.

How did I get from my teary departure to a sold-out display? By remembering that all the artists I felt so intimidated by that day in 1995 had gone through their own small beginnings. Instead of comparing myself to them and concluding they had something I did not, I decided to learn from and be inspired by their experience. Then perhaps my example could encourage another just-starting-out-artist who might be browsing the aisles of a future Yes Store. I had to look beyond that moment of feeling small and "less than" and toward the most positive future I could envision. Once I glimpsed the possibilities, all I needed to do was get back to work.

ARTWORK BY CHRISTINE CASTRO HUGHES

"I DON'T WANT TO BE A DILUTED, HALF-BAKED VERSION OF THE ARTIST I KNOW I WAS BORN TO BE. I DON'T WANT TO FADE OUT, FIT IN, OR FIX THE 'BROKEN' THINGS AND CHANGE. I WANT TO INHABIT THIS SKIN AND LINGER, STAY TETHERED TO THIS GIFT FOR AS LONG AS I'M ALLOWED, FOR AS LONG AS LIFE PERMITS." –ANNE CARMACK

In this age of immediacy—when I am privy to the latest creations, developments, deals, ideas and endeavors of my friends, colleagues and kindred spirits—it takes little or no effort to feel like a small fish in a big, crowded pond that doesn't have enough room for everyone. This leads to feeling like I have to fiercely guard my corner of the pond against invasion, encroachment or intrusion. All it takes is an hour of browsing the Web to fill my head with the comings and goings of everyone else and lose sight of my own unique ideas, creations and perspectives. Before too long, not only am I feeling defensive—sensitive to what others are creating and offering—but also pondering thoughts like, "Does the world really need another book on inspiration and creativity? There can't possibly be room for mine!"

I have experienced these negative thought cycles within myself and observed it in others, and my conclusion is always the same: I am best served by trusting there is enough room for everyone and that my most important work—as a writer, an artist and in any other role I play—is to focus on my *own* work, which will always be wholly unique from anyone else's. I am certainly influenced and inspired by my family, friends and community members (see chapter six for more about this), but aside from simply plucking another's idea and reproducing it verbatim, whatever I offer the world will be unique because it will have my imprint on it, an imprint shaped by everything from my grandma's influence and Japanese pop culture, to a silver sequined dress that hangs in my studio.

McCabe Russell sums it up beautifully when she says, "Let's face it—so much has been said and done before, but not with your spin. Shut the critics out and make your own world—live there, breathe there, create there." After developing a series of art workshops for girls, McCabe began offering a Mermaid Warrior e-course, teaching others how to create their own workshops.

"I decided to share my knowledge with others because I found a need and a formula that worked and wanted to demonstrate that it wasn't necessary to be a professional artist or therapist to sit on the floor and make art journals with girls." Hundreds of women from around the world have soaked up her knowledge and advice and gone on to create their own programs. While McCabe could have guarded her knowledge and experience, she chose to share it. Instead of diluting her dreams and creations, her generosity expanded their positive influence like a sparkling, gently blown dandelion.

To say it more simply: There is no one like me and there is no one like you. There is no one like Penelope Dullaghan, Vineeta Nair, Liz Kalloch or Kate Swoboda. By staying true to myself I ensure that what I give to the world will be unique, special, and one-of-a-kind. As Jamie Ridler says, "Only by being true to you will you discover where you fit just right." There is space in the world available specifically for what I have to offer and that space cannot be filled or taken away by anyone else. There might not have been a space for me in the 1995 Yes Store, but that wasn't because I was untalented or on the wrong path, it simply meant I needed more time and experience to develop my creations. Once that was solidified, the uniqueness of my work was illuminated and I found my place in that community.

66 I find that the more devoted I become to doing my own creative work, the less I need to search for outside. 99

Anne Carmack

"THERE ARE TIMES WHEN I GET CAUGHT UP IN ADMIRING SOMEONE'S WORK AND WANT TO EMULATE IT, WANT TO CREATE THE SAME FEELINGS THEIR WORK INSPIRED, INSTEAD OF ALLOWING IT TO INSPIRE MY OWN UNIQUE ENDEAVORS. OVER TIME, I'VE LEARNED TO CHANNEL THIS INSPIRATION TOWARD MY OWN VISION OF CREATING; I'VE USED IT TO GET CLOSER TO A BRAVE AND EXPANSIVE SPACE WITHIN MYSELF." –LIZ KALLOCH

Whenever I get caught up in negative thought cycles—the ones that tell me there isn't enough room for what I want to contribute to the world and that my voice isn't unique enough—I respond with a few simple yet powerful questions:

Who am I to withhold what only I can offer the world?

Who am I am to refuse to offer whatever inspiration I can because I'm afraid someone might steal it, think it stolen, criticize it, ignore it, or take it as an affront to their own creative pursuits?

How do any of us serve the world by believing we are anything other than magnificently, brilliantly, perfectly unique?

My work is not to try to determine what I think the rest of the world will like, buy, celebrate or approve of. My work is to do my own work. As a writer, my mission is to share my stories in a voice that is uniquely my own. That is my foundation, as opposed to the blind pursuit of magazine bylines or publishing contracts. If I approach my work as a writer for the sake of trying to fit into a space I think will make me popular, not only will it lack substance, depth and authenticity, but it will lead me away from my best, most meaningful work. I have to stay true to my own voice, which means I have to believe in the uniqueness of what I have to say. That is the first and most important step toward finding my place in the world—the place where what I have to offer walks hand in hand with what the world needs, a place that exists for everyone.

89

PHOTO BY
JENNIFER LEE

90

ARTWORK BY PENELOPE DULLAGHAN

Make It Real

"REACHING YOUR PLACE IN THE WORLD IS REACHING YOURSELF. IT'S NOT A FINISH LINE—IT'S A COMING HOME. AND IT DOESN'T HAPPEN WHEN YOU LAND YOUR DREAM JOB. IT HAPPENS WHEN WHAT YOU ARE DOING AND WHO YOU ARE BEING MAKES SENSE, REGARDLESS OF WHETHER ANYONE ELSE IS DOING IT." –VINEETA NAIR

There are beautiful discoveries awaiting all of us as we walk along the path toward our most meaningful life. Abundance, inspiration, opportunities and insights are available to everyone—in every moment—and because each of us is in the process of living a wholly unique life, there is no need to worry that these gifts will be threatened by the success or contributions of anyone else. The more firmly rooted you can stand in your own sense of self and uniqueness, the less you will be inspired to take things personally and consider the actions of others as any kind of affront to your own pursuits, dreams and contributions. "It is about thinking for ourselves, being connected to our core feelings and empowered to act positively and passionately in our world," explains Mary Anne Radmacher. "It is about recognizing that the most important promises are the ones we make to ourselves."

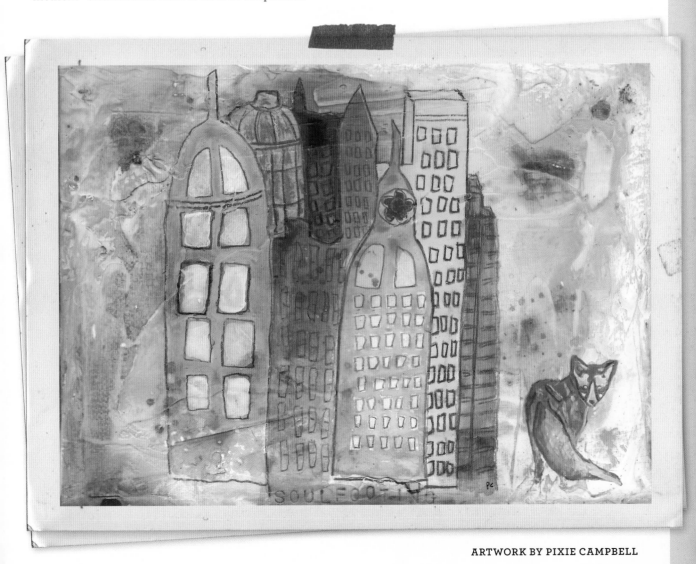

ARTWORK BY PIXIE CAMPBELL

exercises

SIMPLE STEPS

CREATED BY VINEETA NAIR

"IT HELPS IF YOU ARE FLEXIBLE WITH YOUR IDEAS OF WHO YOU ARE AND WHAT WILL MAKE YOU HAPPY. AS LONG AS I THOUGHT ADVERTISING SHOULD MAKE ME HAPPY BECAUSE I DID A COURSE IN IT AND BECAUSE I INVESTED X NUMBER OF YEARS IN IT, I WAS MISERABLE. LIFE IS NOT CONVENIENT. LIFE IS BEAUTIFUL. BUT SOMETIMES IT TAKES COURAGE TO SEE THE BEAUTY." –VINEETA NAIR

Make a list of all the things that make you happy. Underline the things that you feel you could do for the rest of your life, even if you don't feel qualified to do them. Don't judge any of it, just write.

Make a list of those who inspire you, whatever they do—mother, father, wife, daughter, teacher, dancer or pet groomer. What is it about what they do that makes them unique and inspiring?

Keep a visual diary with stories, musings and scenarios of the kind of person you would be in your ideal world. Keep writing in it, even if you repeat yourself, with all the details that you can think of. This can be your own private journal, so dream big.

Smile a lot at the mirror—that's a neat person in there.

Meanwhile, keep doing the things that bring you joy. Don't stop. And if you have stopped doing something that makes you happy, now is the time to start doing it again. Start it and keep at it.

Don't be result oriented. Be joy oriented.

Focus on what is working for you. Time and energy are often wasted focusing on what is not working. Instead shift your focus to what is working—journal about it and continue to put it into practice.

Make a Daily Joy and Gratitude list. Take five minutes a day, maybe first thing in the morning or last thing in the evening, that's all it takes to be reminded of your abundance.

Trust. Take one day at a time.

92

> **"** All I have to do is offer up what comes naturally to me—which is to share my passion for inspiration, motivation and encouragement—and from that I know that no matter what choices I make in my life, my heart voice will be there for me when I'm ready. **"**
>
> Carmen Torbus

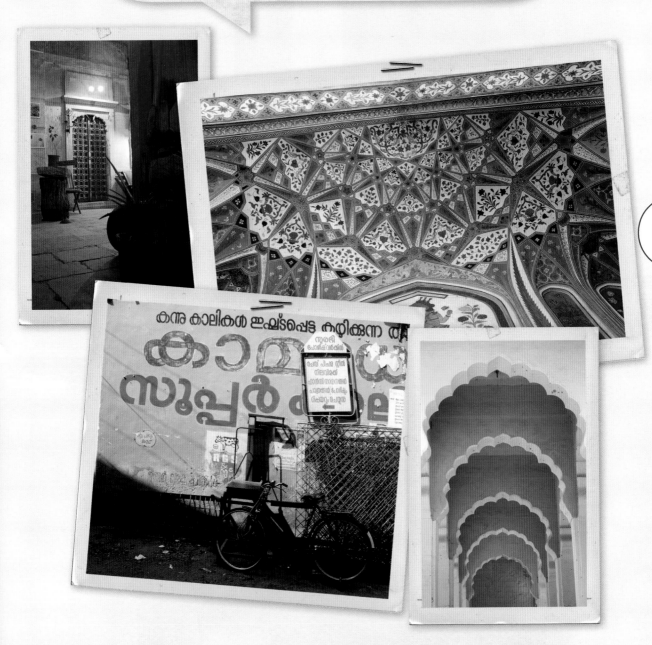

PHOTOS BY VINEETA NAIR

MARKING A MILESTONE

CREATED BY PIXIE CAMPBELL

A month before my daughter was born, I gathered items that symbolized my son's upcoming role as an older sibling to honor his rite of passage. I chose a rocking chair for nurturing and a jar filled with birdseed. I created a deerskin medicine bundle that contained a pouch with one stone for each member of the family, a rose petal for love, lavender buds for calm emotions and two tiny dove feathers to symbolize peace between them. A hawk feather found on my way outside to set up was added spontaneously, which felt like a symbol for guided vision.

My husband led our son out into the garden, seated him on the rocking throne and we presented him with the bundle. I showed him the stones, with a short explanation of which stone represented whom, and then hung the pouch from his neck like a talisman of great importance. It was clear that he was being initiated into a new journey. He happily scattered the birdseed toward the East (considered the direction of new beginnings in Native American traditions), and we all said a few words about what a fine big brother he would make. We said a prayer of thanks and completed the short ritual with a family hug around my big belly.

Rituals serve to celebrate a transition—either with others or in solitude—and can be used on a number of occasions, including:

• A teenage daughter celebrating her sixteenth birthday

• A child heading off to college

• Birth

• Moving

• Divorce

• New business or venture

PHOTO BY PIXIE CAMPBELL

> **66** At any given moment there will always be something you love, something that gives you joy—stick with it, keep at it. Your joy will lead you to the answers you seek. It may be gardening, children, cooking or solving puzzles. If it gives you joy, just do it. And do it with all that you have. **99**
>
> Vineeta Nair

PHOTO BY PIXIE CAMPBELL

GATHER THE BASICS

Choose items relevant to the ritual. They might include:

- Dried herbs to use as an offering of gratitude to nature in exchange for blessings.

- A talisman for the recipient, like a simple charm or necklace.

- An object to place in an area of the home or garden that is sacred, such as an altar.

- Small crystal point or stone known for healing, such as rose quartz or calcite.

- Candle for creative fire.

- Silver dollar for abundance.

- Seashell for acceptance of life's cycles.

- Blue glass bottle of water for purification.

- Fresh or dried flowers.

- A collection of themed gifts from faraway friends and family who would like to participate. For a rite involving transformation, this might be best symbolized by a creature that undergoes metamorphosis, such as a butterfly or dragonfly.

- Small pouch or box to accompany your gift to keep it contained and to hold the memories of the ritual.

OPEN THE CEREMONY

A very simple prayer could be used to open the ritual and set the tone. Draw from the honoree's heritage or faith to create a simple and uplifting atmosphere. Put your family member or friend at ease by choosing language that is familiar and comfortable to them.

MAKE IT WORK FOR YOU

The idea behind a rite of passage is that it's a significant moment on an individual's path. Being honored allows them to be recognized for their potential to overcome new challenges. Be sure to celebrate them with a token of growth to come. Rituals can be somber or playful. Bringing in an element of fun works well for the young at heart and those new to ceremony. Complete your rite with the recitation of a poem, a silent walk through nature, passing around a beverage to be shared, or my personal favorite, a feast.

ARTWORK AND PHOTO BY MCCABE RUSSELL

chapter eight

finding the way through

Believing in Ourselves, One Challenge at a Time

> 66 I secretly want people to let me believe in them until they are ready to believe in themselves because I know that if they could see themselves the way I see them, there is nothing they couldn't accomplish. 99
>
> Carmen Torbus

"I DISCOVERED *1000 JOURNALS* WHEN A FILM PROJECT I HAD WORKED ON FEVERISHLY FOR A YEAR GOT CANCELED, OUT OF THE BLUE. THIS CRASH LANDING WAS PAINFUL AND TRAUMATIZING AND I FOUND MYSELF IN A DEEP, DARK HOLE WITH LOADS OF TIME ON MY HANDS. SO I ROAMED AIMLESSLY—WITHOUT OBJECTIVES, WITHOUT PRESSURE, WITHOUT CONCEPT. I JUST FOLLOWED MY NOSE." —ANDREA KREUZHAGE

With bags packed and a ticket to Canada in hand, filmmaker Andrea Kreuzhage experienced a devastating blow. But just as all the contributors to this book have recovered from similar moments of disappointment, self-doubt, and fear, she found the motivation to get back on her feet and follow her intuition.

"This moment of crisis invited a re-invention, a departure," Andrea explains, "After over fifteen years of producing feature films, I started to write and direct a documentary. This was not my conscious plan and there were unknowns in every aspect of the undertaking. But as I took my first steps, I realized that the bits and pieces of my experiences so far—my training and professional life and my personal interests and passions—had equipped me with the tools I needed. I just had to trust and put them to work in new combinations."

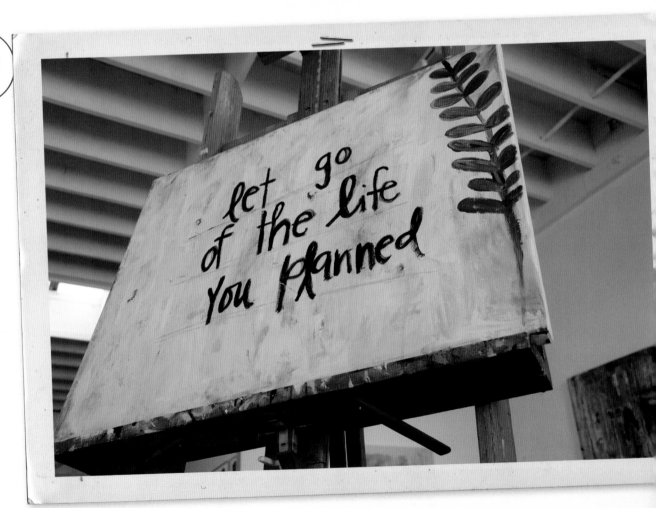

ARTWORK BY CHRISTIEN OLIVAREZ, PHOTO BY CHRISTINE MASON MILLER

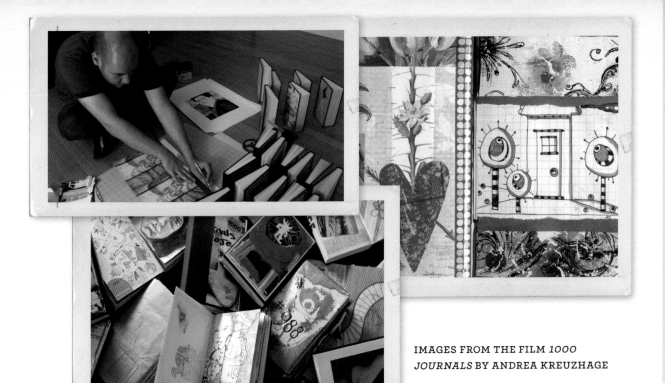

IMAGES FROM THE FILM *1000 JOURNALS* BY ANDREA KREUZHAGE

This trust led to the creation of the film *1000 Journals*, which came to life because Andrea believed in her abilities and was willing to venture into unfamiliar territory despite her recent disappointment and bare-bones budget. "Starting out, I had to use whatever was available to me, so the setup was improvised and simple—an old camera and a thirty-dollar microphone from RadioShack," says Andrea. "The most important thing was getting out to interview people, then analyzing the experience in order to go out again and do it better. This learning curve provided the pathway that led to the creation of the film, which has traveled farther than I'd ever imagined." *1000 Journals* has been shown at film festivals and museums around the globe since its 2007 world premiere and inspired countless other collaborative projects, including a participatory exhibit at the Skirball Cultural Center in Los Angeles and 1001journals.com, where groups and individuals can launch, share and document their own journal projects online. All along, Andrea has continued to put her experiences with *1000 Journals* into practice whenever she comes up against difficult times. "Challenges can inspire you to discover new qualities and talents; they can make you strong, inventive, resourceful and original," she shares. "If I feel inadequate or unable, I remind myself I'm a Beginner and encourage myself to keep experimenting, learning and moving forward."

> ❝ Take a daring leap. Begin to pave your own trail. Listen to the whispers within your heart. Take micro-actions. Commit to change. Take responsibility for how you live your life. Embrace joy and release sorrow. Accept that within this moment, you can rewrite your story by taking one step in a different direction, followed by another step… one action at a time. ❞
> Carolyn Rubenstein

> 66 All it takes is finding the bravery to be true to what's in your heart and in your spirit. It's not always easy (that's the brave part) but it is wonderfully simple. 99
>
> Jamie Ridler

ARTWORK BY PENELOPE DULLAGHAN

"NO MATTER WHAT IS THROWN AT ME, I WILL NOT BREAK. I KNOW THAT WITHIN THE DEPTHS OF MY BEING I AM STRONGER THAN I REALIZE AND THAT STRENGTH WILL ALWAYS GET ME THROUGH EVEN THE WORST OF TIMES AND HELP ME APPRECIATE THE BEST OF TIMES." –CHRISTEN OLIVAREZ

In 2009, Christen Olivarez was faced with a medical issue that required countless tests, needles and other procedures that left her feeling scared, exhausted and depressed. "Getting out of bed each day was a struggle, but I did it anyway," shares Christen. "With each day that passed, it all got a little easier and as my outlook shifted, my health improved as well. Once the issue was resolved, I made a commitment to continue living my life the way I always had, but also allowed myself time to admit how hard the journey had been." Christen's experience—which initially felt harrowing—planted the seeds for a new source of strength and wisdom.

"Until this happened, I hadn't dealt with much adversity at all, so I initially felt ill-equipped to handle it," she elaborates. "But I kept reminding myself that things always happen for a reason and I needed to see this through to understand the deeper purpose. I discovered determination and tenacity within myself that surprised me and learned how strong I truly am."

FINDING COURAGE

BY MARY ANNE RADMACHER

It was a trembled and shaking (as opposed to shaken and stirred!) period of time when I chose to leave the security of a regular paycheck behind and start my own company. And my friend and last boss helped me make the final leap by firing me! That was an illuminating and inspiring time. There was no more "some day" to the dream. It was NOW I AM ... and that was more than twenty-five years ago.

I've been acting in the now of creating ever since.

As the years passed, the complexity of responsibilities for my business grew: employer, tenant, manufacturer, retailer, sales coordinator and creative source. My business went through so many transitions and I started to wonder if what I was doing was "on track" with my vision, if I was making a real difference in the world. That was in August of 2001.

The following October an unexpected inspiration arrived that fuels me to this day. A client in New Jersey called and told me one of the fire stations that had been sending crews to Ground Zero had posted a huge vinyl banner above its doors. That banner featured one of my own quotes:

"Courage doesn't always roar. Courage is the quiet voice at the end of the day saying, 'I will try again tomorrow.'"

Ah. Yes. I am inspired to do, feel, think, believe AND understand and every once in awhile I am blessed to learn that my work makes a difference to someone in addition to myself.

**PHOTOS OF MARY
ANNE RADMACHER BY
MICHAEL STADLER**

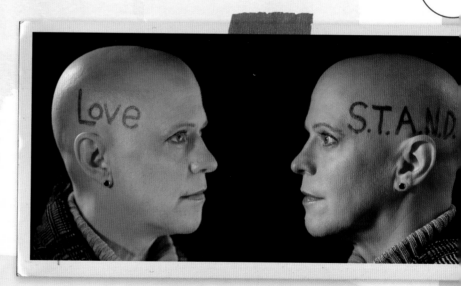

> **❝** I want to stop doing so much to change me. I want to stop believing that there's a 'better,' more practical, watered-down way that I could be. I want to revel in the realization that all of this has made me the artist that I am today. **❞**
>
> Anne Carmack

"THIS THING RIGHT NOW—THIS FEELING, THIS FIRE, THIS FROZEN BRICK OF PANIC AND SHAME—THIS MEANS SOMETHING; THERE'S SOMETHING BREWING HERE. THIS CAN BE TRANSFORMED. THIS CAN BE THE PLACE WHERE YOUR DREAM BEGINS." –ANNE CARMACK

How often has it been said by people I might normally label "victims" that their disasters and traumas provided some of the greatest gifts they've ever received? Things like a cancer diagnosis, the loss of a job, or divorce all appear traumatic on the surface, but more often have the potential to open new doors of insight, wisdom, experience and opportunity that would otherwise remain closed. At their core, moments of difficulty, however great or small, create the same thing as moments of success and triumph: dynamic, transformative energy. Whether a moment instills joy, fear, shock or excitement, it is all energy that I am capable of transforming and using creatively.

The trick is to allow those opportunities for transformation to emerge organically, which usually means spending time in a place of uncertainty, unknown and discomfort. Andrea Kreuzhage redirected the energy from a project that fell through toward an unexpected, uncharted adventure. Had she been unwilling to recognize the possibilities available to her with so much creative energy and a sudden empty calendar, *1000 Journals* would never have been made and the world would have missed out on an extraordinary gift. The first step on that journey involved forward movement without a clear idea of where she was going. Rather than try to immediately fill the space with something specific, she embraced the expanse before her and stepped toward it with eyes and arms wide open.

66 I believe in the magic of the most ordinary moments. I believe that the glow of candles can soothe your soul. I believe in the power of the perfect book. I believe in squishy socks with grips on the soles. I believe in showering by daylight. I believe in late-night chats outdoors. I believe in the sound of laughter. I believe in the warmth of a cozy home. I believe in good food. I believe in family. I believe that handwritten is better than typed. I believe in kindness. I believe that finding your passion will change your life. I believe in the beauty of being a woman. I believe that a snuggle with a cat can brighten the bleakest of days. I believe in working hard. 99

Christen Olivarez

This is not to take anything away from the very real difficulties we face when confronted with sudden changes in our health, work or life at home. Although I am immensely grateful for the lessons I learned and the growth that came as a direct result of my divorce, it was incredibly painful—day in and day out—for a long stretch of time. A simple flick of a switch won't transform emotions that arise out of loss, heartache and disappointment. It is a journey like everything else, where every step counts and every action matters. I remember the exact day—the exact *moment*—I realized it was time to take the sadness, depression and anxiety from my divorce and channel that energy toward positive transformation within myself. Once I recognized this choice was available to me and decided to embrace it, my life began to change in small but potent ways—a steady, patient evolution.

Just as a flower does not burst through the soil in its full-blossomed glory, this newfound wisdom within me unveiled its beauty at its own languid pace, day by day, petal by petal, in sync with every step I took to service its growth.

I am still on this journey. I always will be. With every major struggle I have experienced since then, it is always the same process—working through the pain, the loss, the anger, but then eventually reaching a point where it is time to channel that energy toward something positive. This process is still challenging and I sometimes feel deeply resentful of it ("Why can't I learn my greatest lessons while coasting along the beach on my bicycle?"), but when I think about the alternative— giving in to negativity and drowning in a sense of entitlement to greater ease in life—I see only one choice: to work whatever inner magic I need to work to create positive transformation.

IGNORING THE ODDS
BY CAROLYN RUBENSTEIN

In the world of childhood cancer, the odds are often not in anyone's favor. But during the years I've spent with the children and families facing such prognoses, those who chose not to focus on those odds were the strongest and happiest. They had nothing to gain by focusing on dire, statistical predictions. Instead, they shifted their focus to what was in their favor. Often, that was the beauty of the moment and the unwavering belief that one must never stop living because of a storm.

The lesson I've learned, again and again: Life doesn't wait for us.

Life is a journey that can never be defined by odds. We—not others—choose how we live our lives. If we decide to believe in ourselves, then nothing can diminish our potential. *This is what I know.*

The fundamental elements of any feelings, emotions and experiences provide the raw material for this process. If I am able and willing to move through difficult experiences with confidence in myself and faith in the best of all possibilities, then the opportunities to put this into practice will present themselves. This is true during especially challenging times and also on something as mundane as a day when I simply feel "off." Tracey Clark explains this progression when she says, "Exhausted, weary and discouraged, I still know the place where 'feel good' exists. It's the place I want to be. The bad news, I'm not there this morning. The good news, I know that all it takes to get there again is to keep walking. I will find it soon enough." The first step through any kind of challenge begins within—from believing in myself and my ability to learn, grow and ultimately shine as a result of whatever difficulty I'm enduring. Once that step is taken, the path of positive transformation will begin to unfold right before my eyes.

Make it Real

"FAR TOO OFTEN, WE DON'T GIVE OURSELVES ENOUGH CREDIT. WE'RE STRONGER, WISER AND MORE BEAUTIFUL THAN WE REALIZE." –CHRISTINE CASTRO HUGHES

Life is messy, sometimes really messy. Things break, warp, fall apart, disintegrate, wilt, bend, self-destruct, explode and implode. Roadblocks appear out of nowhere, opportunities are taken away and in spite of it all, the world is still full of stories, creations and experiences that make our hearts shine in recognition of the best and most inspiring that is possible within us. Great, even brilliant, ideas might be easy to come by, but following them through to their ultimate expression takes perseverance, tenacity, grit, passion, commitment and a steadfast, if not unwavering, belief in ourselves and in our ability to creatively transmute a challenge into an opportunity. Whatever the circumstances, transformative gifts await us. Every time.

> **❝ Thinking small and giving in to negativity— particularly toward oneself—does not serve the world. Ever. ❞**
> Christine Mason Miller

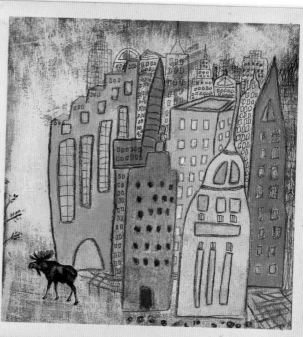

ARTWORK BY PIXIE CAMPBELL

PHOTO BY CHRISTINE MASON MILLER

THE VOICE THAT MATTERS MOST
CREATED BY TRACEY CLARK

"BEING ENOUGH AS WE ARE RIGHT NOW, TODAY, AS IS, IS HARD FOR MOST WOMEN TO REALLY ACKNOWLEDGE AND YET, IT'S THE KEY TO LIVING OUR BEST LIVES." –TRACEY CLARK

Have you ever spent a day in your own head? I mean, really listening to your inner voice? There is a dialogue that goes on all day, every day in our heads. Taking some time to listen to that voice (be it good or bad), will help you better understand whether it propels you forward or holds you back.

PART ONE: LISTEN

Begin this exercise by listening to your inner dialogue for an entire day, taking notes on how you treat yourself. How do you start your morning? How do you react to yourself throughout the day? Do you say the same things to yourself that you would say to your child, partner or cherished friend? In more cases than not, we wouldn't dream of treating those we care about the way we treat ourselves in our own heads. Crazy, isn't it? The good news is that by learning to tune in to the station that's playing in our heads, we also learn how to change the channel.

In my own experience, my inner dialogue went something like this:

"You're giving your kids cereal for breakfast? If you were a good mother you'd make bacon and eggs."

"Why haven't you scrubbed the toilet? If you were a good wife, you'd keep the house clean."

"Sure you're trying to build a career, but you're not a very good photographer and you have no formal training. Who are you kidding?"

And so it went—day in, day out—never giving myself a break or believing I was enough, until a personal epiphany prompted me to radically change my inner dialogue and declare it to the world. "I Am Enough" was the declaration I told myself, my friends, my family and the World Wide Web, thus beginning a life-altering transformation that has touched every part of my life.

PART TWO: CHALLENGE

The next step is to challenge the negative voices—to take the internal trash talk and face it head on. Keep in mind that this is a daily practice—it is not something you can do once and be done with. The goal is to strengthen this skill like a muscle so it gets easier with time.

Sorting out fact from fiction is the biggest trick here. My own gauge for truth comes from my "I Am Enough" declaration. If the voices make me feel like I'm not doing enough or being enough, then I know I have to toss them out. It takes time to dismantle such powerful ammunition, but it's worth every effort.

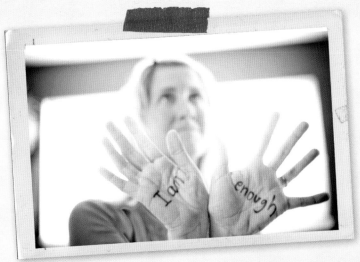

PHOTO BY TRACEY CLARK

PART THREE: AFFIRMATIONS

Because it's nearly impossible to keep the demons away without engaging the angels, the third step is to create your own personal affirmations. These will be the facts that directly confront the fiction. Now that you have a better understanding of what your self-talk triggers are, you can create the words to change them. For me, the phrase "I Am Enough" is one of the most powerful. Once you have established your most powerful phrase or phrases, it's time to sprinkle them all over your life. From art on your walls to Post-it Notes on bathroom mirrors, state your self-kindness intentions loud and clear!

To learn more about Tracey's "I Am Enough" project, visit www.traceyclark. com/iamenough.

66 In order to change the world, or even just one person's life, we must first believe that we can.**99**
Christen Olivarez

I'M A POSITIVE LIGHT SELF-PORTRAIT
CREATED BY JENNIFER LEE

"SOMETIMES IT CAN BE HARD TO SEE HOW POWERFUL, MAGNIFICENT AND BIG WE REALLY ARE; IT'S NATURAL TO FEEL DOUBT AND FEAR. BUT WHEN YOU HIDE JUST HOW BRIGHT YOU ARE, YOU KEEP YOURSELF SMALL AND THE WORLD MISSES OUT ON YOUR SPECIAL GIFTS." –JENNIFER LEE

Try this: Curl up into a ball as small as you can, tightly tucking in your head and limbs. Now, from this constricted position, try to think big, positive, powerful thoughts. Say out loud, "I can do anything!" or "I'm a positive light in the world!" Notice how you feel.

Next, try this: Hold a wide stance, puff your chest out, lift your head up and spread your arms out wide. Again think big, positive, powerful thoughts. Say out loud or even shout, "I can do anything!" "I'm a positive light in the world!". Again, notice how you feel. I bet it was easier and more resonant to say when your body was open and expansive.

Now let's explore your bigness further by creating a life-size "I'm a Positive Light" Self-Portrait.

SUPPLIES: Butcher paper, pencil, markers, poster paints, magazines, scissors, glue stick, glitter

Use a pencil or marker to trace an outline of your body in your powerful stance with legs and arms wide. You can also have a friend help you. Don't worry about getting a perfect line here. We're just going after a general shape.

Decorate the inside of your body with words, images and colors that express your positive light from within. Use the questions that follow as prompts and let your intuition guide you.

What do you love about you? (You could even put loving words on your different body parts—if you make beautiful things with your hands, write that on your palms.)

What are your special gifts or strengths?

What are you most proud of?

When have you felt most alive? What were you doing? What were you feeling?

What are your core values?

What is your essence?

How do you shine brightly?

Write your answers in colorful markers or paint. Include empowering statements or quotes. Collage images that represent you and inspire you to believe in your best self.

If you're having trouble thinking of things to include, ask friends or family members to share a few words to describe you, or invite them to help you decorate your portrait. You could even throw a party where each person decorates her own portrait first and then everyone gets a chance to add to everyone else's piece.

When you're finished decorating the inside of your portrait, step back and spend some time taking in your own bigness. Notice what it feels like to witness your own light. Your portrait is a powerful, creative mirror for you to see how brightly you shine.

If you're so inspired, feel free to decorate the space outside of your body with words or images to describe how you impact the world. You can include your mission statement to remind you of how you touch others simply by being marvelous YOU!

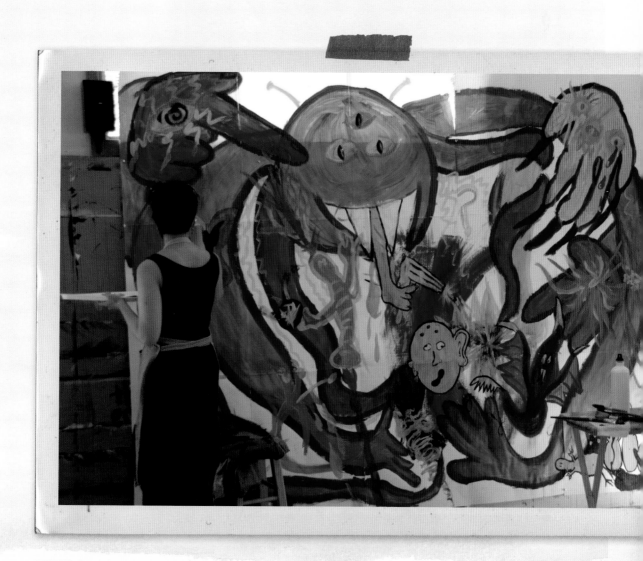

PHOTO OF JENNIFER LEE AND HER ARTWORK BY CHRIS ZYDEL

110

chapter nine

the world outside ourselves

What It Means to Be of Service to Others

66 One person cannot save the world and solve all of its problems, but many people living in service to their highest calling will collectively lift the world and create light where it is most needed. 99
Christine Mason Miller

"BEING OF SERVICE TO OTHERS STARTS WITH BEING EXACTLY WHO YOU ARE. THE WORLD NEEDS YOUR GIFTS." –JAMIE RIDLER

If you are a child of the Seventies like me, you likely have memories of late-night infomercials featuring Sally Struthers walking through a village in Africa, urging viewers to "adopt" a child and contribute enough money to feed them for a year. These images marked an expansion of my awareness about humanity, as I started to understand there was a great big world beyond my backyard where people needed help. I realized it was possible for someone like me—an eight-year-old girl in Jacksonville, North Carolina—to make a difference in their lives.

Around this time my parents were friends with a doctor who was treating a woman living on meager resources, due in no small part to her medical condition. On Thanksgiving day, my parents and I went with the doctor and his family to this patient's house, offering armloads of groceries and a giant turkey, and this day marked another expansion of my awareness. While Ms. Struthers's pleas for just fifty-two cents a day made me think about the struggles and problems that occur in other parts of the world, our visit to this woman's house showed me there were people struggling in my own hometown and it was possible to help them, too. Her doctor, our friend, saw her as a patient and no other work or assistance was expected of him, but he took the initiative to provide a Thanksgiving dinner for her family nonetheless and his example stayed with me.

In chapter one, I described being a Force of Good in the following way:

"It is about honoring our spirits so we can more fully support those around us, and creating the greatest capacity for kindness and compassion toward others by showing the same consideration toward ourselves."

> **66** To be of service to others is to give without hesitation, to the very best of my abilities, in the spirit of what is asked. Whether it be advice or a kind word, I look at it as giving of what I have, what I know and who I am. **99**
>
> Liz Kalloch

ARTWORK BY CHRISTINE CASTRO HUGHES

113

This summation was created from my own thoughts and values as well as those of this book's contributors. The thread connecting all of them—the idea that was expressed over and over again—was the symbiotic relationship between caring for oneself and caring for others. When I follow my deepest calling, my heart glows and that light and energy is a Force of Good that is capable of traveling far and wide. Which means that when I take care of myself, I am taking care of those around me and, by extension, the entire world.

Like the stories shared in chapter six, this light and energy creates a beautiful ripple of inspiration that encourages others to take action on behalf of their own deepest calling. By becoming closely acquainted with my most important values as discussed in chapter two, surrendering to the inevitable twists and turns outlined in chapter five and continuing to believe in myself in the midst of challenging situations such as those in chapter eight, my ability to be a Force of Good in the world can grow and evolve in ways I likely can't imagine. That journey begins with one step, which is to take care of myself the way Mindy Tsonas expresses: "By being brave with your life and striving to always honor your values, you manifest strength and meaning that ultimately enriches the lives of others."

So what is the difference between being a Force of Good in the world and being of service to others? After poring over the answers everyone shared for this topic, I saw a subtle but important difference—while being a Force of Good was an act that began with oneself and proceeded to flow broadly outward, being of service to others was about keeping one's senses open and receptive to where something specific was needed and offering what one could to the best of one's abilities and most reflective of one's passions. Some examples:

"To be of service … means keeping our eyes and hearts open so we can see an opportunity to help." -Christine Castro Hughes

"Being in service first starts with deep listening. What are you and your community yearning for? When what the world needs aligns with what truly lights you up, then you've found your 'Be in Service' sweet spot." -Jennifer Lee

"It means asking what is needed and then doing what I can, using the skills and resources I have, to help meet that need." –Marianne Elliott

"It is sharing your talents, heart and passion in meaningful ways to inspire and bring out the best in others." –Carmen Torbus

"To be integrated to yourself is to be integrated to your purpose; being in service to others is no different from being in service to yourself." –Vineeta Nair

"There are so many needs in the world that if I were simply dedicated to general service, I would sleeplessly, endlessly be engaged in nonstop activity. My service to others is connected to my highest skill set. When I do what I do best—for another—that service sings. And it assists the one served in being their best. It is a well-aimed action that precisely hits its mark." –Mary Ann Radmacher

If being a Force of Good is about discovering the light within and letting it shine in as many directions as possible, then being of service to others is about directing that unique light where it is most needed. When a boat approaches a rocky shore, a full moon can guide it up to a point, but as it gets closer—or if it encounters rain or fog—it is the lighthouse, with its bright, carefully aimed spotlight, that brings it directly to shore. The extraordinary feat each of this book's contributors have managed to accomplish is not only finding their strongest, most meaningful voice and sharing it with the world, but also uncovering all the nooks, crannies, communities and people that need their gifts the most and taking their work to those corners of the world. Rather than merely ask, "What does the world need?," these women asked, "What parts of the world need what I have to offer to the best of my abilities, passions, talents and callings?"

PHOTO OF CHRISTINE MASON MILLER (L) BY KINDRA CLINEFF

66 To be in service to others is really no different from doing work that serves the self. The work we do to transform who we ar helps to transform the world and vice-versa. Once I got that—that behind every action, something is contributed to the world, which will either build myself and others up or tear everyone down— then I saw myself playing a much bigger game on the planet. 99

Kate Swoboda

I happened to be born on a certain date, in a certain part of the world and I grew up to develop certain interests, passions and values. All of these details have shaped my ability to be of service to others, and while I know I cannot solve all the problems of the world, I can be of service in a variety of ways. I've donated artwork to charitable auctions, raising money for everything from breast cancer research to inner-city music programs. I've created handwritten wedding invitations for family members and shipped packages filled with goodies to friends serving in Afghanistan, turning even my quaint love of snail mail into a meaningful source of service. You also happen to be holding a manifestation of another form of passionate service—writing. If I look at all the things I love most, it takes little or no effort to see the ways they have been used, shared and expressed in service to others.

I never "adopted" one of the children Sally Struthers talked about in her Seventies era public service announcements, but those images impacted me nonetheless. Over time, I have learned how to more precisely aim my talents, skills, values, resources and passions toward those parts of the world where I can make the biggest difference and provide the most meaningful service, which is sometimes within the walls of my own home. By living in alignment with my most important values, there will be no shortage of opportunities to fully express them in a way that serves the greatest good. As I learn to more immediately identify them, I create an ever expanding, always evolving flow of energy that unites my gifts with the world's needs in a beautiful partnership.

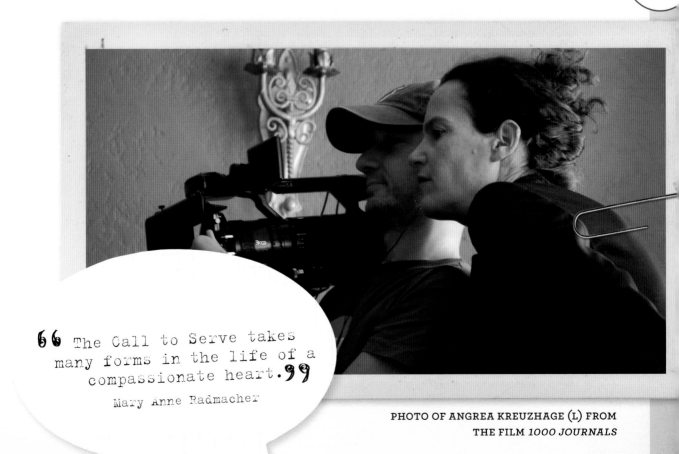

66 The Call to Serve takes many forms in the life of a compassionate heart. 99
Mary Anne Radmacher

PHOTO OF ANGREA KREUZHAGE (L) FROM
THE FILM *1000 JOURNALS*

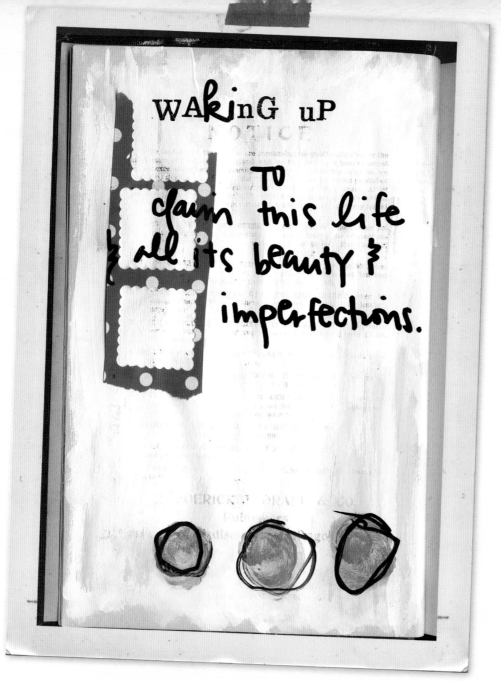

ARTWORK BY CHRISTEN OLIVAREZ

66 Being in service to others means giving people what they need most. I think I have a unique approach where this is concerned. Because I so enjoy inspiring people to look at their lives differently—with a refreshed, positive and grateful perspective—I feel like that is my service 'calling'. 99

Tracey Clark

Make it Real

"ONE DAY I WAS SITTING AT A STOPLIGHT AND A MAN IN AN ELECTRIC WHEELCHAIR BUZZED BY. HE WAS STRUGGLING WITH HIS OXYGEN TUBE AND COULDN'T GET IT HOOKED UP ON HIS EARS. RIGHT THEN—SEEMINGLY OUT OF NOWHERE—A WOMAN IN HIGH HEELS WITH A PERFECT HAIRCUT WALKED OVER, SET HER GUCCI BAG DOWN IN THE DIRT AND HELPED HIM—REALLY HELPED HIM—TUCKING AND TOUCHING AND PUTTING THAT TUBE RIGHT IN ITS PLACE. THESE TWO PEOPLE BARELY SPOKE TO ONE ANOTHER, BUT SOMETHING MAGICAL HAPPENED AND HIS WHOLE WORLD CHANGED. FOR THIRTY SECONDS, EVERYTHING WAS KINDNESS, EVERYTHING WAS GOOD. IT IS THOSE KINDS OF EXPERIENCES WE CAN'T STAND TO FORGET; IT IS THOSE EXAMPLES WE NEED MORE OF." –ANNE CARMACK

In this story, Anne shares an experience of observing one woman noticing that the person in front of her was in need of assistance. While this was a tiny episode in time—likely taking less than a full minute—it speaks to the awareness this book's contributors spoke of when they shared their thoughts on being of service to others. The woman Anne observed did nothing more than tuck some tubes behind a man's ears, but even that incredibly small action made a difference. Imagine the positive differences that can be made when we take our strongest passions, our highest callings, and our most powerful skill set and share them where they are most needed and can have the greatest impact. When we hear our voice calling, our heart stirs and we are inspired into action; the same kind of stirring occurs when we recognize where these actions will make the greatest difference. Both are moments of feeling our intuition vibrate and letting its momentum carry us.

PHOTO BY MINDY TSONAS

BODY TRACKING

CREATED BY MARIANNE ELLIOTT, ADAPTED FROM AN EXERCISE TAUGHT BY SEANE CORN, HALA KHOURI AND SUZANNE STERLING AS PART OF THEIR *OFF THE MAT, INTO THE WORLD* CURRICULUM.

"BEING OF SERVICE IS ABOUT CREATING SPACE AND SOFTNESS IN MY BODY, MIND AND SPIRIT BECAUSE MY BEST SERVICE COMES WHEN I AM SPACIOUS AND SOFT. IT MEANS BEING WILLING TO TAKE CARE OF MYSELF, WHICH IS A SERVICE TO EVERYONE AROUND ME!" –MARIANNE ELLIOTT

We all share a fundamental, natural compassion, which is often the primary motivation behind our desire to serve. But other forces—including things we may find less admirable, like fear or guilt—also play a part in our motivation. If we want our service to be effective and sustainable, then we need to be willing to look at those other, "shadow," motivations.

What I've learned is that when I do something to "help" someone else, but do it with a feeling of fear, guilt or pity, the quality of my service is compromised. As well as having a different effect on the "recipient" of my efforts, this kind of service also drains me and I can't sustain it. Body tracking is one of the tools that I find most helpful for noticing the motivations that are present when I want to be of service.

This is a very simple exercise: For one week pay careful attention to your body whenever you are doing, or about to do, something of "service." These could be small things, like agreeing to run an errand for a friend, or bigger things, like offering your online course on a pay-what-you-can basis. Get into the habit of scanning your physical body, including your breath, to notice what's going on.

Notice what it feels like physically when you are acting with fear or guilt, resentment or obligation. How are you breathing? What sensations are you feeling in your body? What do you feel in your limbs? Your belly, chest and throat? This is not an invitation to judge the sensations or the emotions behind them. It's an invitation to get really curious about what happens in your body and what that might be telling you.

PHOTOS OF MARIANNE ELLIOTT BY LUCAS PUTNAM

Once you notice what's happening in your body, stay with the sensations for a moment. Perhaps even exaggerate the sensations for a short time, to get a better feel for them. Which part of your body is contracted? Is that a familiar feeling? Do you often find yourself tight in that spot? Just notice.

Then let it go. Inhale deeply through your nose, feeling space open up in your body, and as you exhale gently release that tension, softening your body and mind.

The purpose of this exercise is not to "get rid" of anything other than a pure compassionate motivation for service. Instead the purpose is to become more aware of those other forces and their effect on our bodies.

Once we notice this, we might choose to find a daily practice that helps us release the tension that builds up in our bodies from the accumulations of these moments. For me that practice is yoga and it's a way to wipe down my physical and energetic slate so that I can show up "clean" in my service to others. When I'm regularly releasing the tension that builds up in my body, I'm better able to hear the prompts of my natural compassion and I can serve from that place.

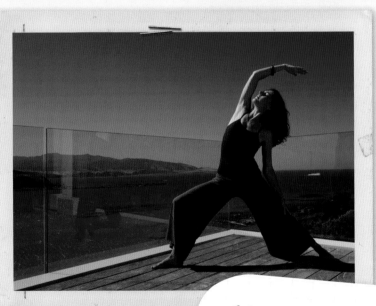

66 For me, being in service to others means practicing loving-kindness and remembering that at any given time, I am only able to see a sliver of the whole picture. And with that in mind I try to act from a place of sympathy, patience and goodwill, giving to others as if I were giving to myself. 99

Penelope Dullaghan

THE GIVING JAR
CREATED BY MINDY TSONAS

"WHAT IS IT THAT YOU MOST WANT IN YOUR LIFE? MAKE IT YOUR PRACTICE TO GIVE JUST THAT." –MINDY TSONAS

For each of us, our brightest light shines from that place where our core values and passions intersect. Finding the source of this light is the key to giving our greatest service to the world. By thinking about what we desire we are given the answer to what we are best meant to offer. This exercise is a fun way to guide your discovery!

SUPPLIES: Jar (or other pretty container), blank slips of paper, pen, journal

STEP 1: WRITE DOWN YOUR DESIRES.

As you go about your daily life, notice from moment to moment what you might be longing for and write down what really resonates, such as, "I want to have more creative time for myself" or "I can't stop thinking about that pink pashmina!" Don't over-think or ruminate about what it is you want—this is not to judge or measure your desires! Simply note them when you encounter them and slip them into your Giving Jar. It's great to always have a pen and some scraps of paper on hand so you can capture these on the go.

STEP 2: PRACTICE GIVING YOUR DESIRES TO OTHERS.

When your Giving Jar begins to fill, start giving! Choose one slip of paper randomly from your jar and think about how you could put this gift out into the world. This is where you will begin to see what you value and how you can act upon it.

If the item is something abstract, like an experience or feeling, think about how you could bring this alive in someone else's life in your own unique way. If the desire is for something more tangible and concrete, think about what particular qualities of that item set your heart afire. You can then use these qualities as the platform for your offerings as they will likely represent a true and authentic you! Take the example of the pink pashmina mentioned earlier—maybe pink is your favorite color and it could become your signature hue, or maybe you like its warmth and coziness and decide those are important qualities for you to convey in serving others.

STEP 3: GATHER THE DETAILS.

Be sure to scribble down all of these important details as you unearth them. Some might be obvious while others might come to you by complete surprise. As you piece them all together, these insights will help you to see a clearer picture of what you ultimately value and are most passionate about. Following through on the creative ways to manifest them is the next big step! By giving to others what you desire, you create an unending and virtuous circle of fulfilling and selfless service.

> **66** The best way to inspire and teach is to live the lessons you are sharing. It is not about being perfect or having it all together. When you step into your own power and stay there, this assists others in finding their power. **99**
>
> McCabe Russell

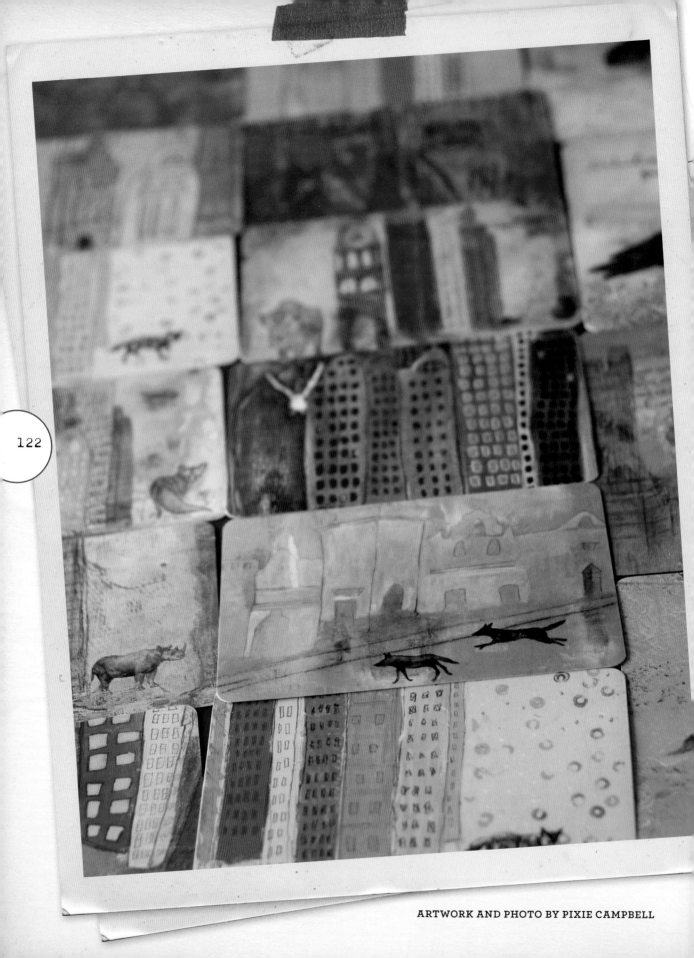

122

chapter ten

declarations & intentions

Creating a Personal Mission Statement

I have a fondness for maps; more specifically, for figuring out exactly where I am on one. When I moved to California and drove along the Pacific Coast Highway for the first time, I loved being able to accurately visualize where I was on a map of the United States—moving precisely along the line separating land and ocean. My passion for travel has given me countless opportunities to "find myself" on maps all over the world—in Berlin, Havana, Tokyo and Amman. And while on flights that take me across continents, I pore over the airline's flight patterns in their in-flight magazine. I even love watching my journeys unfold in real time on my iPhone GPS.

Seeing where I am on a map provides a basic point of reference. I know where I am in relation to this street, that monument, my own house, or a subway station. One of the most panic-inducing situations I've ever encountered on my travels was becoming separated from my group in Buenos Aires and realizing I had no map. After a few moments of feeling like I had no idea where I was *in the entire world*, it suddenly dawned on me to hail a cab. (To this day I'm immensely grateful I remembered the name of my hotel.) But until the anxiety-induced fog cleared, I felt absolutely paralyzed. Not knowing Buenos Aires, there was nothing in my

immediate vision that could give me an idea of where I was. As far as my knowledge of the city was concerned, every street I saw could have led to the ends of the earth and the buildings could have been cardboard cutouts. They were meaningless to me in terms of understanding where I was because I had no map to refer to.

With a map in hand, not only do I know where I am, I can also figure out where I want to go. I am given a bird's-eye view, able to see what my options are and consider what will be the best route and destination according to my immediate needs. On my last trip to Tokyo, I wanted to find my way to the used bookstore section of the city, an area I wasn't familiar with; I made it there thanks to the subway map. In Los Angeles, my goal is usually trying to figure out a route from point A to point B that will keep me away from the worst traffic. Many different purposes, all requiring the same thing: something to show me where I am, where I'm going and how to get there.

A mission statement is like a map—it is a reference I can turn to whenever I am lost, need guidance or want more specific assistance on whatever journey I'm taking. Each time I have created a mission statement, whether for a business, a book or myself, I always think of it as a road map of sorts, only I'm the one drawing the map (which means it will likely change and evolve). No matter what its original purpose or inspiration, every mission statement I've created has rewarded me in the same fundamental way—by showing me the way home, even when I feel totally lost.

PHOTO BY CHRISTINE
MASON MILLER

MAP OF THE WORLD

PHOTO BY LIZ KALLOCH

"THERE ARE SO MANY WAYS TO BOIL DOWN OUR PERSONAL MISSION, OR INTENTIONS, AS I OFTEN REFER TO IT. OFTEN THERE IS MORE THAN ONE. DISTILLING ALL THE THINGS WE WOULD LOVE TO DO MOST WITH OUR LIVES, IN A BIG-PICTURE KIND OF WAY, CAN HELP US DISCOVER AND DEVELOP OUR OWN PERSONAL MISSION STATEMENT." –TRACEY CLARK

I have been working with mission statements throughout my adult life. I helped create one for the first women's organization on the campus of Virginia Tech and for a variety of programs in graduate school. I had a mission statement for Swirly and an artist statement for my mixed-media work. I wrote one for every book proposal I've assembled and recently started a discussion with my family about creating one for ourselves—as a family. Each has been an important tool regardless of the context because it provides, if nothing else, a marker I can always turn to for guidance.

So what does a personal mission statement need to say? What questions does it need to answer? How can one statement encompass everything—values, passions, talents and dreams? If it is supposed to serve as a map of my soul, guiding me along my journey, what should that look like?

Here is what it is not: static, unmoving, inflexible, immobile, permanent, definitive, rigid or absolute.

Here is what it is: ever changing, ever shifting, ever evolving, elastic, soft, pliable, receptive and adaptable.

While I have developed mission statements specific to various projects and roles, my personal mission statement hasn't varied much in years and it speaks to five core values. (See chapter two for more about core values.) I frame my personal mission statement as an "I would love..." statement, a tool given to me by a personal coach.

I would love to live a mindful life of integrity, where my day-to-day words, actions and choices reflect my core values: honesty, compassion, creativity, gratitude and personal responsibility.

PHOTO BY JAMIE RIDLER

> **"** A good personal mission statement can express what you hope your life—and the way you live it—says about you. It can be a reflection of what you want to put out into the world. Without listing specific goals, it can provide a guidepost that can lead you where you want to go in a way that is most meaningful to you. **"**
>
> Christen Olivarez

PHOTO BY MCCABE RUSSELL

While my core values have remained constant, their flexibility has enabled me to apply them to a wide array of circumstances and situations—some big, some small, some celebratory, some excruciating (which is where my commitment to my core values is truly put to the test). Having a mission statement to guide and direct me is a powerful tool, but does not necessarily mean my decisions will be easy. After experiencing many weeks of unexplainable health issues, I made the decision to cancel a trip to Cuba in the spring of 2007. I lost money, disappointed a friend and turned down an opportunity to go to one of my favorite places in the world, but I came to that decision after a thoughtful consideration of my core values and highest priorities. At the time, my health was my top priority, and while there was a very strong urge to toss that aside and focus all attention on my lust for travel, another big priority, I knew in my heart that if I went I would be going against my personal mission statement. It would not have been a decision based in honesty ("I really don't feel so bad"), it was not rooted in compassion (toward myself), and it would not have been a responsible choice—creating risks not only for myself, but also my fellow travelers and tour guide. Turns out this was the right decision, as my health issues intensified—and required immediate attention—literally the day I was supposed to leave.

A mission statement won't provide any guarantees or make things necessarily easier in the moment, but it always enables me to narrow down my options when faced with a dilemma. On the surface this might seem limiting, but when trying to resolve a personal or professional conundrum, it is actually helpful to remove certain options from my list when I recognize they do not reflect my values and priorities. As Mary Anne Radmacher explains, "A personal mission statement delivers clarity as to whether one should say YES or NO to a specific opportunity. It helps speed recovery from the inevitable bumps and bruises of life."

JAMIE RIDLER ON CREATING A PERSONAL MISSION STATEMENT

In my work as a coach I see many driven people wrestling with the concept of purpose and mission, all the while standing still. This is not helpful. I know. I've been there. Here's what I suggest.

Ground yourself in self-knowledge, then pick a direction and go!

Make a list of things you love. Collect images that move you. Take yourself on long walks and little adventures. Take a dance class. Write a poem. Throw a party. Volunteer. Try something. It doesn't have to be the absolute most perfect thing from the moment you start. It just has to be a beginning. Set out on an adventure that calls to your heart. You'll get signals that will help you course-correct along the way. As you gather your experiences and your reactions, as you discover your loves and delights, as you find people and places where you fit just right, as you stay true to who you are and what you bring to the world, your mission will come to light before your eyes just as a work of art reveals itself to the artist through the process of creation. Instead of a slog through the muck looking for an answer, make discovering your personal mission statement an adventure in discovery.

Be who you are. The rest will follow.

> **❝** It is so easy to lose sight of the course you've plotted for yourself and who you truly are deep inside. A personal mission statement can empower and inspire you and it will definitely keep you on your course. **❞**
> Liz Kalloch

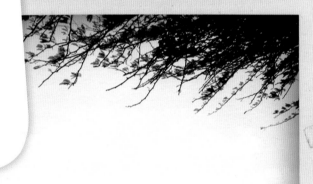

you get many chances

PHOTO BY VINEETA NAIR

GLOBAL EXPERIENCES, PERSONAL REVELATIONS
BY MARIANNE ELLIOTT

I'm still in the process of working this out myself, but it seems to me that a personal mission statement needs to answer these three questions:

1. WHAT IMPACT DO YOU WANT TO HAVE ON THE WORLD?

This might be really specific and concrete like "a cure to cancer" or "healthier food in schools" or something broader like "more connection" or "create beauty." One thing I've learned is that our deepest longing to be of service in the world may very well be the fruit that has grown from our most painful experiences, so being willing to look at the hard parts of our lives can help us get clear on the answer to this first question.

2. WHAT NOURISHES YOU? WHAT BRINGS YOU ALIVE AND FILLS YOU WITH JOY?

This is the key to a sustainable personal mission. It doesn't matter how "worthy" our intention is; if the kind of work we do—or the way we do that work—depletes us, then our mission is unlikely to be sustainable for us. Build awareness of what gives you joy into your mission and you will not only sustain your work, but—even better—you'll thrive!

3. WHAT RESOURCES DO YOU HAVE RIGHT NOW?

It's likely that your personal mission will involve you accessing all sorts of amazing new resources whether in the form of collaborators, information or money. But to get started it helps to ground your mission in the resources you already have—both within yourself and those you can draw on from outside.

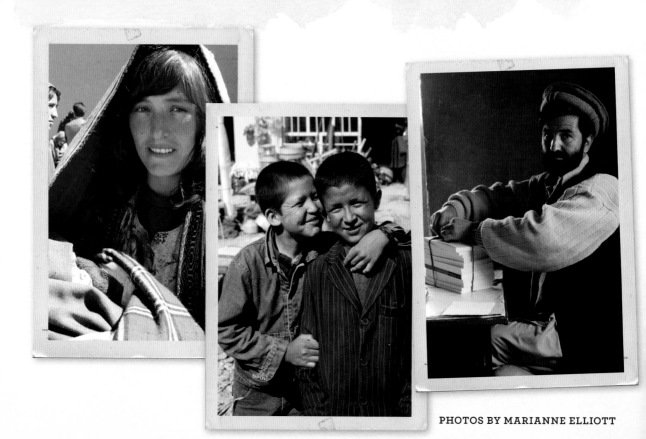

PHOTOS BY MARIANNE ELLIOTT

PHOTO BY MINDY TSONAS

allow no
limitations to
be defined on
your behalf

imagine what you can. become.

mary anne radmacher

ARTWORK BY MARY ANNE RADMACHER

"MAKE YOUR MISSION STATEMENT A GROUNDED, PRAGMATIC VISION STATEMENT. A RECIPE FOR YOU TOMORROW." —ANDREA KREUZHAGE

Could I live a productive, inspiring and meaningful life without a mission statement? Of course. But without a road map to guide me through whatever endeavor I'm pursuing, frustrations, unexpected twists and even a simple off day have that much more potential to throw me way off-kilter. I've found that with a mission statement in place, I have something concrete to remind me of my deepest purpose. On the days when my head starts spinning over deadlines, roadblocks and other noise, it keeps me focused on what is most important. While writing one was certainly a good first step toward putting my core values into action, it has been the work of putting them into practice—day in and day out—that has kept my mission statement relevant, powerful and meaningful.

Make it Real

"BE WHO YOU ARE. THE REST WILL FOLLOW." –JAMIE RIDLER

Long, long ago, sailors had to navigate their way around the world by the stars—sparkles of light in the sky that gave them the points of reference they needed to make their way to their destination, which was sometimes back home. What are your points of light? Are they clearly defined? Become deeply acquainted with your most important values—your guideposts—and you'll always know where you stand.

ARTWORK AND PHOTOS BY LIZ KALLOCH

66 Creating a personal mission statement can come from the most intuitive place within. When it reflects what is in your soul to express, it will honor you with drawing to you the medicine that is just right for you. 99

Pixie Campbell

THE MISSION STATEMENT INVENTORY

Beyond the very basic mission statement guidelines shared in this chapter, there are endless avenues that can be taken to develop a mission statement. While working on this book, I asked each contributor, "What questions does a good personal mission statement need to answer?" From their answers, I've compiled the following Mission Statement Inventory. Rather than feel like all of them need to be answered for a mission statement to be "good," I suggest seeing which questions you are drawn to—and which ones you strongly resist. Both will provide valuable insights. Pick two to three and work with those. See where they take you, follow their lead.

- What are my non-negotiables?
- What do I need to prosper as an individual (and what does "prosper" mean to me)?
- What does my heart want?
- What does my brain want?
- What inspires me the most?
- What do I value?
- Where should I devote my time and energy?
- How do I want to be remembered?
- What is my essence?
- What are my special gifts to the world?
- What do I stand for?
- What is the unique impact I have on others?
- What must I do?
- What is the single most significant thing that I contribute to myself and others on a daily basis?
- What are the things that I will consistently do in order to support and realize that?
- What do I want to offer?
- Why am I going to do what I do?

- What events and experiences sparked this?
- What are my core values?
- What is my big dream in life?
- How do I wish to be of service in the world?
- What qualities make me unique and special?
- What can I do every day to move forward on my journey?
- What really matters?
- Does this bring me vitality?
- Is this the medicine that heals and energizes me as I walk my path?
- Does it express what is at the core of myself and my intention creatively enough?
- What was I born to do?
- When I read my personal mission statement, how do I feel?
- What things bring me joy?
- Where do I find my deep inner satisfaction?
- What things am I truly good at? (Don't be shy!)

(Contributors to this questionnaire: Carolyn Rubenstein, Christine Castro Hughes, Jennifer Lee, Mary Anne Radmacher, McCabe Russell, Mindy Tsonas, Penelope Dullaghan, Pixie Campbell, Tracey Clark and Liz Kalloch.)

VISIONING
CREATED BY CARMEN TORBUS

"IT ALL STARTS HERE: WHO AM I AND WHAT DO I HAVE TO OFFER THE WORLD?" –CARMEN TORBUS

Visioning is a powerful exercise to meet yourself where you are. It is also an excellent tool for getting real about where you're headed. When thinking about a personal mission statement, visioning can be a great place to start.

SUPPLIES: One of the following: a visioning partner, a video camera or voice recorder.

PLAN AHEAD
Doing this every week or twice a month is ideal; set a schedule and stick to it.

WITH A VISIONING PARTNER
Partner with someone you can count on to hold you accountable—someone who can positively motivate you to stick to your visioning schedule.

Plan a schedule for your visioning calls or in-person visioning sessions and be sure to choose a time that will be free of interruptions. Set a time limit of forty-five minutes to an hour and commit to beginning and ending on time.

132

At the beginning of each session, take a few moments together to clear your mind and decide who will go first.

Then begin asking and answering the visioning questions out loud:

1. What is your greatest vision for your life? (Instead of "life" this can be business, artwork, project, writing, etc.)

2. What are your next steps for realizing that vision?

3. What kind of support do you need?

4. How will you make sure you will keep going?

Take notes for each other during this time. When it is your turn to answer the questions, don't take notes for yourself. Your only work is to answer the questions honestly and out loud. After each session, rewrite the notes you took for your partner in the form of a positive letter and send it to your partner. You can take it a step further by taking the notes your partner sends you and rewriting them yourself as an affirmation.

PHOTO BY CARMEN TORBUS

VISIONING TIPS

Resist planning ahead for your session.

Go with your gut and answer each question accordingly.

Stay open and loose; don't hold back.

Visioning with a partner requires vulnerability. When you trust and embrace this process, growth is bound to happen.

WITHOUT A VISIONING PARTNER

Plan a schedule for your visioning sessions and, again, be sure to choose a time that will be free of interruptions. Set a time limit of thirty minutes.

At the beginning of each session, take a few moments to clear your mind with a few deep breaths.

Turn on your recorder or video camera and ask yourself the same visioning questions listed above. Play back your recording and take notes as you would for a partner, then rewrite your notes in the form of a positive letter to yourself or as a positive affirmation.

Whether visioning with a partner or on your own, consider sharing your vision with the world on your blog or online video platform. You'll be amazed how empowering this is!

PERSONAL EXPERIENCE

I've tried this as a written, "freewriting" or "brain dump" kind of exercise, but usually found myself thinking too much and not always writing what came up. The verbal element of this exercise is harder and makes me feel more vulnerable. The good news is that these uncomfortable feelings can be transformed in magical ways. There's something about saying it out loud that makes it more real and creates a bigger impact.

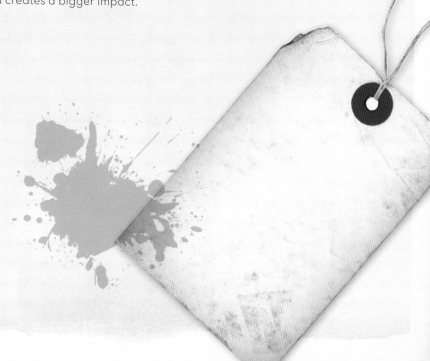

TWO QUESTIONS
CREATED BY ANNE CARMACK

"BY CREATING A PERSONAL MISSION STATEMENT YOU ARE TAKING THE TIME TO INVESTIGATE THE VALUES UPON WHICH YOU WANT TO BUILD YOUR LIFE."
–ANNE CARMACK

If you have found your way to this book, chances are you're a creative spirit seeking some guidance. Although doing the research and working through exercises like this one will be key to creating the kind of inspired life you have in mind, it is very important to remember that so much of what you are searching for is already within you.

Because we are all so different, there is no "right" way to do this exercise. Even though I know your final mission statement will look very different from my own, it is helpful if we both begin from the same place:

We will ask ourselves: Who am I and what do I value most in this world?

Here's my answer: I am an artist, I am a writer, I am brave and I value time—time to breathe, time to think, time to work on art. I also value honesty, the support of my friends and family and the ability to be keep going, even when I'm terrified. I am and I do many things, but when I sit down to begin my day, it is my answer to that question I think about.

Now it's your turn. Take a moment to write down three (or more!) things you know yourself to be and the three things you value most. You can make a simple list, write a paragraph on each, or say them loud into a microphone! I find that it's easiest to have these words close by; I keep mine in my journal and daybook. Figure out what works for you! This unique reminder will become the constant basis for all of your most important choices, empowering you to hold steady in the face of life's ever-changing ways.

Now that you've created your basic outline, your purpose is in focus and you can center your life around that. For example, I declared myself to be a writer, so I can see that it is important to work on writing every day. I'm committed to a life of bravery and can remind myself to stay courageous when the doubt sets in. If I put a value on making the time to paint, but constantly find myself walking the dog, washing the dishes and playing on the computer, I know I'm not living from a place that is loyal to my mission. On the rough days—and there have been many—I've referred back to my personal philosophy, my declaration of who I want to be and what kind of bold, courageous, fearless things I want to do with my day.

Good luck!

PHOTO BY ANNE CARMACK

Pixie Campbell

Artist & Writer • Bakersfield, CA • pixiecampbell.typepad.com

Anne Carmack

Artist & Photographer • Santa Monica, CA • folkandfable.com

Christine Castro Hughes

Artist & Graphic Designer • Los Angeles, CA • darlingstudio.com

Tracey Clark

Photographer, Shutter Sisters founder & Author of *Waiting for Baby* and *Baby of Mine*•Long Beach, CA • traceyclark.com • shuttersisters.com

Penelope Dullaghan

Artist, Commercial Illustrator & Creator of Illustration Friday • Winona Lake, IN • penelopeillustration.com • illustrationfriday.com

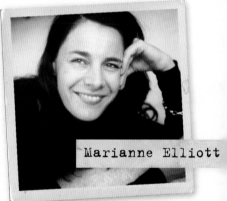

Marianne Elliott

Writer, Human Rights Advocate & Yoga Teacher • Wellington, New Zealand • marianne-elliott.com

Liz Kalloch

Artist & Designer • San Rafael, CA • athenadreams.typepad.com/design

Andrea Kreuzhage

Documentary Filmmaker & Director of *1000 Journals* • Los Angeles, CA • 1000journalsfilm.com

Jennifer Lee

Professional Coach & Author of the forthcoming *The Right-Brain Business Plan* • San Francisco, CA • artizencoaching.com

Vineeta Nair

Artist & Designer • Mumbai, India • artnlight.blogspot.com

Christen Olivarez

Artist & Director of Publishing for Stampington Publications • Laguna Hills, CA • thedeliberatelife. typepad.com • stampington.com

Mary Anne Radmacher

Artist, Writer & Author of *Promises to Myself, May Your Walls Know Joy, Courage Doesn't Always Roar, Live Boldly* and *Lean Forward Into Your Life* • Clinton, WA • maryanneradmacher.com

Jamie Ridler

Professional Coach & Creator of Soul Reflections Workshop and Your Creative Spark Inspiration E-Pack • Toronto, Canada • jamieridlerstudios.ca

Amy Krouse Rosenthal

Writer & Author of *Encyclopedia of an Ordinary Life* and multiple children's books • Chicago, IL • whoisamy.com

Carolyn Rubenstein

Founder of Care. Commit. Change Scholarship program & Author of *Perseverance: True Voices of Cancer Survivors* • Boston, MA • abeautifulrippleeffect.com • springinspiration.com • cccscholarships.org

McCabe Russell

Artist & Workshop Leader • San Diego, CA • dancingmermaid.com

Kate Swodoba

Personal Coach & Workshop Leader • San Francisco, CA • yourcourageouslife.com

Carmen Torbus

Artist & Author of forthcoming *Seeking Artistic Style: Art-Making Exercises to Uncover Your Creative Signature* • Port Saint Lucie, FL • carmentorbus.com

Mindy Tsonas

Creator of the *Wish Studio*, an online creative community • Newbury, MA • wishstudio.com

about christine mason miller

Christine is a mixed-media artist who founded her own stationary company, Swirly, in 1995 and since then has evolved into a line of licensees, freelance clients and retail partners including Target, Andrews McMeel Universal, Borders, Barnes & Noble and Girl Scouts of America. She self-published her own book, *Ordinary Sparkling Moments*, in 2008 and is a contributing artist in Taking Flight by Kelly Rae Roberts, *Art Saves* by Jenny Doh and *The Artist Unique* by Carmen Torbus. Visit Christine's web site at christinemasonmiller.com.

gratitude

I would like to thank North Light Books, most especially Tonia Davenport and Julie Hollyday for their support, guidance, and belief in my vision.

I offer a Hollywood sign-sized thank you to each of the book's nineteen contributors for their passionate insights, examples, and support, all of which have, indeed, transformed the world.

Many thanks to Amy Friedman and Maya Stein, whose influence and encouragement have inspired, improved, and strengthened my writing practice.

For spiritual guidance and inspiration, I would like to acknowledge and thank David Davis, Karen Maezen Miller, and Helene Finizio.

For staying true, showing up, and being there—always—I would like to thank Melissa Piccola.

To the Garlands—Carrie, Jim, Bayley, Ellie, Jack, and Benjamin—for teaching me what it means to embrace and embody limitless possibility.

For opening their hearts, home, and family, I thank Sebastian and Milah.

Immense gratitude to Justin, Nita, Taylor, and Christos—never doubt that you are deeply loved and always treasured. It is your ever-sparkling light that always guides me home, even on the darkest of nights.

And to my dearest, Lawrence—there are no words to express how grateful I am that we found one another in this great big world of ours. You have given my heart a home and helped me write the most extraordinary story of my life.

PHOTO BY ANNE CARMACK

index

www.fwmedia.com

15 14 13 12 11 5 4 3 2 1

DISTRIBUTED IN CANADA BY FRASER DIRECT

100 Armstrong Avenue

Georgetown, ON, Canada L7G 5S4

Tel: (905) 877-4411

DISTRIBUTED IN THE U.K. AND EUROPE BY F&W MEDIA INTERNATIONAL

Brunel House, Newton Abbot, Devon, TQ12 4PU, England

Tel: (+44) 1626 323200, Fax: (+44) 1626 323319

E-mail: enquiries@fwmedia.com

DISTRIBUTED IN AUSTRALIA BY CAPRICORN LINK

P.O. Box 704, S. Windsor NSW, 2756 Australia

Tel: (02) 4577-3555

SRN: Y1766

ISBN 13: 978-1-4403-1073-7

Edited by Julie Hollyday

Cover design by Ronson Slagle

Interior design by Megan Richards

Production coordinated by Greg Nock

METRIC CONVERSION CHART

To convert	to	multiply by
Inches	Centimeters	2.54
Centimeters	Inches	0.4
Feet	Centimeters	30.5
Centimeters	Feet	0.03
Yards	Meters	0.9
Meters	Yards	1.1

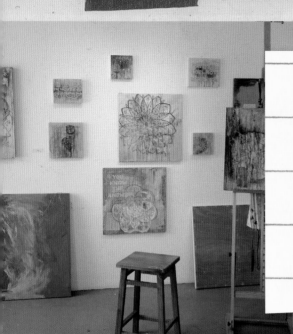

Discover more inspiration with these North Light Books

Unearth the clues to discovering who you are, how you got here and where you wish to go.

Art has a way of giving you beauty, meaning, spiritual richness, community...even salvation.

Experience the creative energy of the art retreat—brought to you in your own studio.

NORTH LIGHT BOOKS